FAITHFUL DEPARTED

The Dublin of James Joyce's *Ulysses*

FAITHFUL DEPARTED

The Dublin of James Joyce's *Ulysses*

Recaptured from classic photographs and assembled by
KIERAN HICKEY

with an introductory essay by
DES HICKEY

THE LILLIPUT PRESS

DUBLIN

Published in 2004 by
THE LILLIPUT PRESS LTD
62–63 Sitric Road, Arbour Hill,
Dublin 7, Ireland
www.lilliputpress.ie
in association with
THE NATIONAL LIBRARY OF IRELAND

First published in 1982 by
WARD RIVER PRESS LTD
Knocksedan House
Swords, Co. Dublin

Original design by Liam Miller
Printed by LEGO of Vicenza

A CIP record for this title is available from The British Library.

ISBN 1 84351 044 8

FAITHFUL DEPARTED is also the title of an award-winning film directed by
Kieran Hickey, written by Des Hickey and produced by B.A.C. Films Ltd, Dublin.

ACKNOWLEDGMENTS
Grateful acknowledgment is made for the brief quotations taken from
The Jews in Ireland by Louis Hyman (Irish University Press 1972).
Grateful acknowledgment is also made for the assistance of the National Library of
Ireland in relation to Robert French's photographs from the Lawrence Collection,

KIERAN HICKEY was born in Dublin in 1936 and died in 1993. He was a documentary film-maker with a special interest in James Joyce and in Irish literature. His principal films, *Faithful Departed* (1967) and *The Light of Other Days* (1972), were based on the photographs of Robert French from the Lawrence Collection of the National Library of Ireland; both gave rise to books of the same name.

DES HICKEY was born in 1929 and died in 1991. Writer, broadcaster, script-writer and travel correspondent, he edited and co-authored several books, including *The Sinking of the Lusitania*, *My Life with Brendan Behan* by Beatrice Behan, and the first biography of John B. Keane.

In memory of
Louis Hyman and
Jack MacGowran

TODAY'S FILM CAMERA CAN RECORD the moving life of a city. At the turn of the century the camera was still, yet one man used it so skilfully that his photographs gave Dublin a life that seems real even today.

The glass negatives of Robert French were the property of the firm of William Lawrence of Sackville Street. Today more than 40,000 of them are the preserve of the National Library of Ireland; the Lawrence Collection is part of the nation's heritage.

Hundreds of these negatives were used in the documentary film *Faithful Departed*, narrated by the late Jack MacGowran, to recreate the Dublin of James Joyce's *Ulysses*. In this book they are reproduced again, with a narration that has become an expanded text, to recreate the life and manners of the city through which Leopold Bloom and Stephen Dedalus moved on June 16, 1904. These are the 'fadographs of a yestern scene'.

'HOW MANY! ALL THESE HERE once walked round Dublin. Faithful departed'.

The thoughts of Leopold Bloom in James Joyce's novel *Ulysses* when they buried Patrick Dignam in Glasnevin cemetery. The day was Thursday, June 16, 1904, the day on which, for Joyce, time stood still.

The sun shone that day. There was a light breeze from the sea. The forecast had been for an unsettled day with 'some fair intervals', but in the afternoon the weather became warm.

Dubliners read in their newspapers that morning of flags at half mast in New York city in mourning for the hundreds reported dead in a fire on board a steamer in the East River; of Japanese troops, despite casualties of 500 killed in one day, at the gates of

Port Arthur; of a senator's son killing himself after his attempt to assassinate the Governor of Finland in the Senate at Helsingfors; of a prankster throwing a lighted match into Mr. Opel's car at Hamburg during preparations for the Gordon Bennett Race and turning the street into a running wall of flame.

Nothing much, however, was happening in Dublin.

The newspapers next day would record the death of Anastasia Weekes, dearly beloved wife of Charles de Renzy Weekes of Palmerston Park, and the birth of a daughter to the wife of Dr. Albert E. Griffith of Terenure.

Court cases were run of the mill, though with a distinctly local flavour. A vanman continued his action against the builders of the North British and Mercantile Insurance Company's headquarters on the corner of Dawson and Nassau Streets (a building that has changed hands on a number of occasions, but preserves its 1904 Palladian frontage); he claimed he was 'laid up' for thirteen weeks when timber fell on him from the building. A cabinetmaker's daughter from Kilkenny was awarded £200 in a breach of promise case; a 'reasonable, but not ruinous' award in the opinion of the judge. The station master at Tara Street sued a Longford cattle dealer for intent to defraud the station booking office on June 15; instead of a shilling the cattle dealer had tendered a medal.

The stores were holding early summer sales. The Henry Street Warehouse had four thousand garments to clear at half price, parasols in all colours from 2/11 and men's umbrellas from 1/11. Todd Burns of Mary Street had 'bargains in every department'. Hickeys of North Earl Street announced 'a great summer clearance sale'.

Racing enthusiasts believed the Ascot Gold Cup that afternoon

would be a duel between Lord Howard de Walden's Zinfandel and the 'dead cert' Sceptre, especially if they accepted the 'prophecies', as they were termed, in the sports pages of *The Freeman's Journal.* Throwaway, however, beat them into second and third place, winning by a length in 'one of the biggest surprises ever known in connection with the race'.

At the theatre that evening the energetic Mrs. Bradman-Palmer, who on Wednesday night had played *Hamlet,* performed *Leah* with her 'specially selected London company'. She played to a full house at the Gaiety and the papers would report next morning that her performance 'in the pathetic part of Leah was exceedingly effective and called forth repeated bursts of applause from the audience.' It was sufficient encouragement for her to take on *Mary Queen of Scots* the next evening.

At the Tivoli on Burgh Quay The Mysterious Lilith shared the bill with the 'inimitable comedian and raconteur' W. J. Churchill. The great Marie Kendall filled the Empire in Dame Street, perhaps the only theatre with which you could make your bookings by telephone (Dublin 824); you could also park your bicycle without charge.

The Elster Grimes Grand Opera Company, which would continue to tour the British Isles well into the 1920s, staged *The Lily of Killarney* at the Queen's Royal Theatre in Brunswick Street. 'A large audience attested the popularity of the Benedict opera', and the papers would report that 'most of the solo items were encored'.

At the Theatre Royal Eugene Stratton 'delighted the audience with his nigger songs and dances'. The same audience poured into Hawkins Street afterwards humming his latest success, *I May Be Crazy, But I Love You.*

Out in the fashionable seaside suburb of Kingstown Walter George's light opera entertainers, known as The Smart Set, were making a return visit. Everything, the billboards promised, would be 'new and up to date'. Admission to the new Kingstown Pavilion with its roof garden and promenade was a mere sixpence and for those who wished to make the trip from the city a combined rail and admission ticket could be purchased for one shilling.

On the surface no stirrings of twentieth century nationalism were apparent, save for a small advertisement that morning inviting Nationalists of Drumcondra Ward to a meeting in the parochial hall at Glasnevin at eight p.m. 'for the purpose of placing on the forthcoming register the names of all Nationalists.'

Dublin, after all, was the second city of the Empire.

In the post war gaiety that followed the Boer campaign it became a society playground. The Dublin season preceded the London season, the Viceregal pageantry rivalled the glamour of the Court. All that Dublin lacked, or so it seemed to the privileged classes, was a Parliament.

Like other European cities the streets were fouled with horse dung. Poverty, alcoholism and syphilis were prevalent. In a population of more than a quarter of a million people thousands were dying from consumption. Yet Dublin was livelier and more distinctive than many European cities.

It had, it was claimed, the most advanced tramway system in the world. The last of the horse trams had vanished three years previously and the electric trams that went clanging from their terminus at the Nelson Pillar, the great Doric monument built just a century earlier marking the city's centre, bore the names of expanding suburbs–Rathmines,Rathgar,Donnybrook,Dalkey, Sandymount, Kingstown, Palmerston Park, Harold's Cross.

'The good lady,' said a guide book of the day, 'can take her pennyworth beside the little seamstress, and if one sits opposite the washerwoman for a quarter of an hour a different impression is created of this estimable personage.'

The tickets on these democratic trams were penny blue, twopence white, threepence pink, fourpence green and fivepence buff. The trams stopped at every crossing and if you were nippy enough you could board or leave them at will.

IN THE DISTANT SUBURB of Dalkey, south of Kingstown, in a private school on Dalkey Avenue with views of the distant bay, the near-sighted young James Joyce was teaching English Literature. The school was not far from Torca Cottage where Bernard Shaw had lived, nor from the winding Vico Road, the name of which evoked the medieval philosopher Giambattista Vico whose theories are woven into the fabric of *Finnegans Wake*.

Joyce was a slim, nervy graduate of twenty-two with weak blue eyes, an aggressive chin, shabby clothes and a bitter sense of humour. His childhood had not been the happiest. He had no recollections of his beginnings in the suburb of Rathgar, but he could remember his childhood in Bray, another watering place further south of the city than Kingstown or Dalkey, with an esplanade, lined with hotels and boarding houses and reaching to the foot of a whale-like hill, along which fashionable women in large hats and wide skirts strolled during summer afternoons. It was in Bray that his aunt, an abandoned bride, railed vehemently against Parnell, the Irish leader who had been betrayed by his people as Joyce himself was to feel betrayed. The aunt became Dante in *Portrait of the Artist as a Young Man* and reputedly struck a man on the head with her umbrella because

he had taken off his hat when the brass band on a circular stand below the esplanade played *God Save The Queen*.

Joyce's adolescent years were spent on the unfashionable north side of the Liffey. As his father's fortunes waned the family moved from one residence to another, usually with speed and secrecy. They moved first to Fitzgibbon Street (not far from Belvedere College where Joyce was to receive a Jesuit education), to Mill-bourne Avenue, to North Richmond Street (where he spent a couple of months at the Christian Brothers' school), to Windsor Avenue, to Richmond Avenue, to Royal Terrace, to Glengariff Parade and back to Royal Terrace.

Joyce senior liked to boast that he had 'sixteen or seventeen children'; in fact he had ten, four boys and six girls. James, or 'Jim', was to be consumed by Dublin just as he was to consume the city in his books — the granite buildings, the peeling brick tenements, the stinking lanes, the wide thoroughfares, the grand parks and the river —Anna Livia.

As his artistic convictions asserted themselves he rejected the Catholic faith, the Jesuits who had educated him without payment, his family, his friends and his literary acquaintances who were busy with the Celtic revival. The growing band of nationalist writers were 'a bunch of chickens behind a high fence'. To Joyce the enthusiastic Yeats, Synge, Colum, O'Sullivan and Russell were perpetrating 'a fraud'. In *Ulysses* he was to symbolise the cultural desert which Dublin had become for him in the story of two crones who climb the 134 steps of the spiral staircase of the Nelson Pillar, the city's tallest monument, to spit plumstones on the citizens below. Dublin, Joyce announced, was suffering from 'hemiplegia of the will'.

xiv

DEPARTED

ON THE AFTERNOON of June 16, 1904, Joyce may have taken one of the electric trams from Dalkey into the city and bought a fivepenny buff ticket, the dearest ticket for the longest journey. Some biographers seem convinced he had spent the night in the Martello Tower at Sandycove. Richard Ellmann, however, suggests he had stayed with friends in Ballsbridge, closer to the city, having left his room in Sandymount because he couldn't pay the rent. He was on his way to meet a tall, redhaired Galway girl named Nora Barnacle at the corner of Merrion Square and Clare Street.

He had first seen Nora on June 10 in nearby Nassau Street; she worked as a chambermaid in Finn's, a small hotel in South Leinster Street, on the stretch between Nassau and Clare Streets. He had stopped to make conversation with her and she mistook him in his jaunty secondhand yachting cap and worn tennis shoes for a sailor. She agreed to meet him again on Wednesday, June 15, but Nora failed to keep this first appointment. Joyce, 'quite dejected', wrote to her that evening and on the following day she was true to her word. On the evening of June 16 the couple went walking together. They walked down to the Liffey and on towards Ringsend. After that they met regularly.

Nora had left school at fourteen. Though she was a girl with a strong sense of humour she had no interest in books. She was to be mistress and then wife to Joyce for thirty-seven years, yet she was never to read *Ulysses*, the novel of 260,430 words in which he immortalised the day of their walking out. She was even heard to say, 'I told Jim to give up writing and become a singer.'

Joyce was fond of singing, in public and private, and had a good, though not strong, tenor voice. He once asked Oliver St. John Gogarty to get him an engagement at the Kingstown Pavil-

ion, where, on the evening of June 16, The Smart Set were entertaining a large audience, riding on the 'high reputation' they had earned themselves in the previous season. Joyce wove into *Ulysses* the favourite concert songs of the period — *M'Appari, I Dreamt I Dwelt in Marble Halls, The Young May Moon, La ci darem, Love's Old Sweet Song*. He came second to the aspiring young John McCormack at the Feis Ceoil, the city's annual music contest. Nora Barnacle could never forget that McCormack and her husband had sung on the same platform.

Four months after their first meeting Joyce and Nora sailed from Ireland to begin life together, first in Zurich, then in Trieste. Joyce took his leave with a dramatic air of finality, yet he had made previous departures from Dublin and was to pay further visits to his native city between 1909 and 1912, all unsuccessful, all soured by imagined plots and intrigues against him. After that, he would test his memory when visitors arrived from Dublin by naming the shops along the principal streets.

WHEN *ULYSSES* WAS PUBLISHED reviewers said it was like trying to read a directory. Joyce had forgotten nothing and invented nobody in the Dublin he hated but could not forget — except perhaps the olive-skinned advertising man Leopold Bloom, warm in his black clothes on that June day. Not a fat middleaged man as some imagine, but a handsome man still in his thirties, Bloom was nonetheless the father figure Ulysses to the Telemachus of Stephen Dedalus. But where had he come from?

Biographers and students of Joyce have made guesses — among them Louis Hyman in his Joyce chapter in *The Jews in Ireland* and Peter Costello in his Bloom 'biography'. Joyce made Bloom the son of an Hungarian Jewish emigrant and an Irish Catholic

mother. Bloom and his sensual wife Molly are given two children, a daughter Milly, and a son Rudy, short-lived, born at the time they lived in Clanbrassil Street, the main shopping street in the Jewish quarter that extended over the square mile bounded by the Grand Canal on the south and the Liberties on the north. Camden Street was the eastern boundary and to the west the ghetto petered out before Dolphin's Barn.

Joyce took names for his characters from *Thom's Directory* for 1905, a major source book. One of the authentic names in the novel is Alfred Hunter. It was Hunter, a Dublin clerk, who came to the rescue when Joyce was beaten up by a young man to whose girl friend he made advances on the night of June 22, 1904; he took Joyce home and attended to his black eye, bloodied face and sprained ankle and wrist. Hunter was a Samaritan, but no Jew, as some biographers have believed. He was a Catholic who married a Margaret Cummins in the Catholic church in Rathmines in 1898.

There were numerous Blooms listed in *Thom's*, none of them necessarily related. There was a Joseph Bloom, who married a Sarah Levy in Cork, living with his wife and five children at 3 Blackpitts, off Lower Clanbrassil Street in the 1890's; this Bloom deserted his wife and went to South Africa. The background of a number of Blooms was traced by Louis Hyman; these included a Solomon Bloom, whose son worked in a photographer's shop in Wexford and may have prompted the idea of Leopold Bloom's daughter Milly working for a photographer in the Midlands, and a Benny Bloom who traded in religious pictures and was known as 'the canvasser'. Joyce may have used these Blooms, among others, as a basis for the Bloom of the novel. And Molly may well have been Daisy, the music teacher, wife of Isaac Blum, a leather

merchant of Desmond Street, off Lombard Street West.

In *Ulysses* Bloom conjures up the names of other Jewish exiles, including Citron ('poor Citron') of St. Kevin's Parade, Moisel ('High price too Moisel told me') of Arbutus Place, and Mastiansky ('with the old cither'). Israel (not J., as listed in *Thom's*) Citron was a veteran of the Boer War who did not return to Dublin until 1916 and was invariably hard-up. Mastiansky was Pinchas (not O. as in *Thom's*) Masliansky (not Mastiansky), a pedlar draper who played the cither. Nisan (not M.) Moisel was a poultry dealer who lived in Arbutus Place, a cul-de-sac off Lombard Street West. Joyce may have met some of these Dublin Jews through his university friend John Francis Byrne, the Cranly of the novels, or heard of them through Byrne's chess activities and his talks to the Dublin Young Men's Zionist Association in Lombard Street West. He may also have drawn on the researches into Judaism in Ireland by his friend John Wyse Power, the John Wyse Nolan of *Ulysses*, the only Gentile in the *Cyclops* episode who is not an anti-Semite. But in spelling the names as listed in *Thom's* Joyce lapsed into using the incorrect initials.

On June 16, 1904, the papers reported that a James Wought, a German emigrant, with addresses in Warren Street and Lower Clanbrassil Street, had been charged with obtaining money by false pretences from Jews in England by posing as an emigration agent supplying tickets to Canada. Wought had stayed at the house of a Mrs. Levin under the name of Saphiro or Spiro, paying three shillings a week for his bed. He had also stayed with a Mrs. Cohen who stated that she had received letters addressed to him in various names at her 'lodging house for Jews'. Mrs. Cohen gave her evidence in Yiddish which was translated by a Selig Bloom of Lower Clanbrassil Street.

Poring over the newspapers of the day in his researches for *Ulysses* Joyce came across this case and turned it into the 'Canada swindle case' in the novel. Wought was later sentenced to twelve months imprisonment with hard labour.

Totally authentic is Moses Herzog, the Jewish pedlar in the *Cyclops* episode. Herzog, the novel's Polyphemus, was known to steal out of the exhausting high holyday services in the little synagogue in St. Kevin's Parade and head for Fitzpatrick's pub on the corner of Donovan's Lane. He was a one-eyed bachelor and, according to one of Louis Hyman's informants, once rebuffed a matchmaker who tried to marry him off to an unattractive woman with the riposte, 'Even one eye wants to see something decent.'

Yet Louis Hyman was convinced that Joyce knew 'very little' about Jewish life in Dublin before he left for Trieste. In researching his *Ulysses* chapter for *The Jews of Ireland* Hyman traced so exhaustively every family with the name of Bloom, or Blum, living in Dublin during and before 1904, 'always circling the mythical Bloom', that the critic Bernard Benstock came to the conclusion that 'the uncomfortable fact presented itself that Louis Hyman knew infinitely more about Dublin Jewry than James Joyce could have suspected'.

Hyman laid stress on Joyce's friendship with John Francis Byrne. Through Byrne Joyce must have met, or certainly heard stories about, the one-eyed Moses Herzog. Byrne was friendly with Abraham Zaks, a junk shop owner who happened to be an extremely learned ordained rabbi and an accomplished chess player. According to Hyman, Joyce used to go to meet Byrne to the DBC restaurant where Byrne and Zaks played chess; and then he and Byrne would 'go perambulating through Dublin'.

Bloom, to Hyman, is the only fictional Jew in the novel. Even Hyman's great-aunt, Minnie Watchman, merits a mention in *Ulysses*. The theme of the return to the Jewish homeland, which recurs through the book and is paralleled by the wanderings of Bloom and Dedalus, prompted Hyman to search for the original of the pork butcher Dlugacz who sells Bloom the kidney for Molly's breakfast wrapped in a newspaper page carrying a pro- spectus for a settlement in Palestine. Dlugacz was a pupil of Joyce's in Trieste, an ardent Zionist who tried unsuccessfully to interest Joyce in the cause. Joyce, who was opposed to the notion of nationalism, simply laughed at the idea. Hyman traced Dlu- gacz's daughter to Haifa and discovered that the Dlugacz refer- ence in *Ulysses* was intended as one of Joyce's private jokes. Dlugacz's is the only Dublin shop in the novel which did not exist.

Molly Bloom is probably part Daisy Blum the music teacher. But Hyman also wondered if Joyce could have met Joseph Bloom's grass widow Sarah, who was said to have turned to prostitution on the streets of Dublin. One Jewish correspondent of Hyman's reported seeing Sarah Bloom and her eldest daughter soliciting near the Nelson Pillar early in 1907.

In the last interview he gave in Dublin Hyman indicated that he had not abandoned his search into the origins of Joyce's characters. He was determined to trace the origin of Bella Cohen, the madame of the Nighttown brothel. Joyce named her Bella, but in *Thom's* her first name is not listed. She had a second house on the esplanade terrace at Bray, which may have been her private address, with South Tyrone Street in the city as her 'business' address. Hyman had puzzled for some years over Bella Cohen. The name Cohen in Ireland is not specifically Jewish and he thought it unlikely that she belonged to the Jewish community

that had arrived in Ireland from Lithuania before the turn of the century. Today Bella Cohen remains one of the unsolved mysteries of Dedalus's Odyssey.

Undoubtedly the anti-Semitic violence of 1904 in Limerick, never too friendly a city for Jews, influenced Joyce whose kinsman Daniel O'Connell had the statute *de Judaismo*, which prescribed a special form of dress for Jews, repealed in 1846. He makes Leopold Bloom, nominally a Catholic, yearn for the Jewish homeland, Eretz Israel.

The isolation of the Jew in exile becomes a parallel to Joyce's own artistic exile. In *Ulysses* he turns the 20th century Everyman into a Jew. After that the term 'Irish Jew' could no longer be considered contradictory.

WHEN THE NOVEL came out in Paris in 1922 Dubliners, catching a rumour of Bloom's Odyssey through their city, asked, 'Are we in it?' They were all in it — businessmen, politicians, shopowners, sandwichmen, publicans, prostitutes, soldiers, constables, pawnbrokers, cabmen, dancing masters, beggarmen, students on the National Library steps, girls on the suburban beaches.

The embittered exile, still only thirty-eight, had paid off his old scores, real and imaginary, though mostly imaginary. *Ulysses* revealed the crowded world of Dublin's middle and lower middle classes who must have been surprised to learn that their behaviour, as described by Joyce, was 'a litany of filth' to the majority of critics.

'The book of a queasy undergraduate,' declared Virginia Woolf, 'scratching his pimples.' 'Talent prostituted to the most vulgar uses', wrote Edmund Gosse. To Yeats it was 'a mad book'

and Bernard Shaw suggested that if *Ulysses* were an accurate description of Dublin the city should be razed to the ground and the foundations sown with salt. At last dear, dirty Dublin was also infamous. In some quarters the novel was considered an 'unprecedented liberation of suppressions' and 'a violent interruption of the Irish literary renaissance'. The city had been too real a place for Joyce to view it through the fashionable Celtic mists. He truly believed that he had fought single-handed every social and religious force in his native city.

Yet how true was his boast that he had endeavoured to provide a picture of Dublin so complete that if the city one day disappeared from the face of the earth it could be reconstructed out of his novel? Not quite true. *Ulysses* is concerned only with certain areas of the Dublin of 1904, and the author's descriptions are not those of the painter. Joyce lived in Dublin only until the age of twenty-two and he can not have explored the place thoroughly. We do not know from reading *Ulysses* what Dublin looked like. Joyce does not describe in topographical detail Nighttown or Sandycove or Trinity or Little Britain Street or Eccles Street or Clanbrassil Street or Glasnevin. To readers not natives of that city the book can be a puzzlement indeed.

However, at the time the novel was germinating in Joyce's creative mind a journeyman photographer, Robert French, working for the firm of William Lawrence in Sackville Street, close to the General Post Office, was photographing every building and streetscape in the city that seemed to him of consequence. The Dublin of the period is preserved for posterity in his glass plates as surely as the behaviour of its citizens in the pages of *Ulysses*.

It would be far easier to reconstruct the Dublin of 1904 from the Lawrence Collection than from the pages of Joyce's novel.

DEPARTED

When Joyce and Nora Barnacle packed their bags and set sail for Zurich in 1904 Joyce took Dublin and its people with him. Even in exile he continued to be obsessed with the city and his imagined betrayers who walked its streets. When the city became 'a mist in my brain' he sought the help of other Dubliners, particularly his aunt Josephine Murray, to fill in the details.

Years later he would ask, 'Have I ever left Ireland?' Just like his attitudes and beliefs Dublin was frozen in his memory on the day time stood still. June 16, 1904 was the day that separated Dedalus the lover from Bloom the husband, the day Joyce fell in love, the day Nora 'made me a man'. 'A day like any other — yet all days in one'. Bloomsday.

How many! said Mr. Bloom. *All these here once walked round Dublin. Faithful departed. As you are now so once were we.*

Dublin rooftops

1

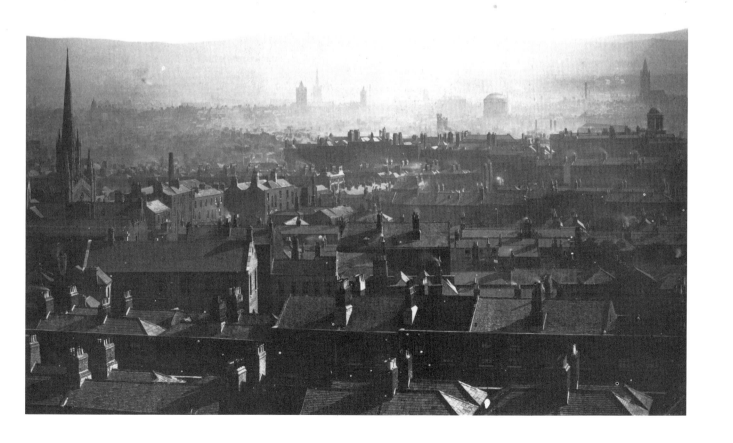

O'Connell Bridge, Sackville Street & Nelson Pillar

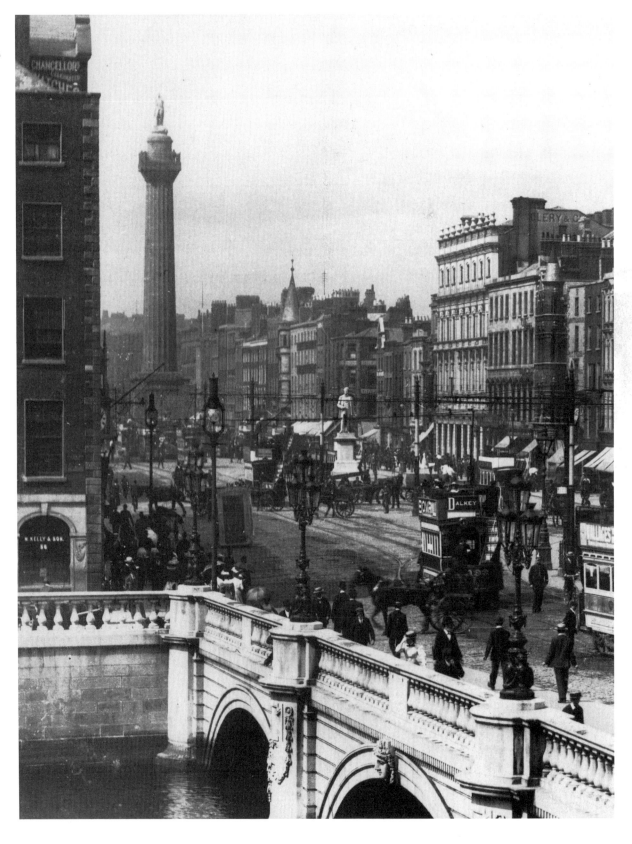

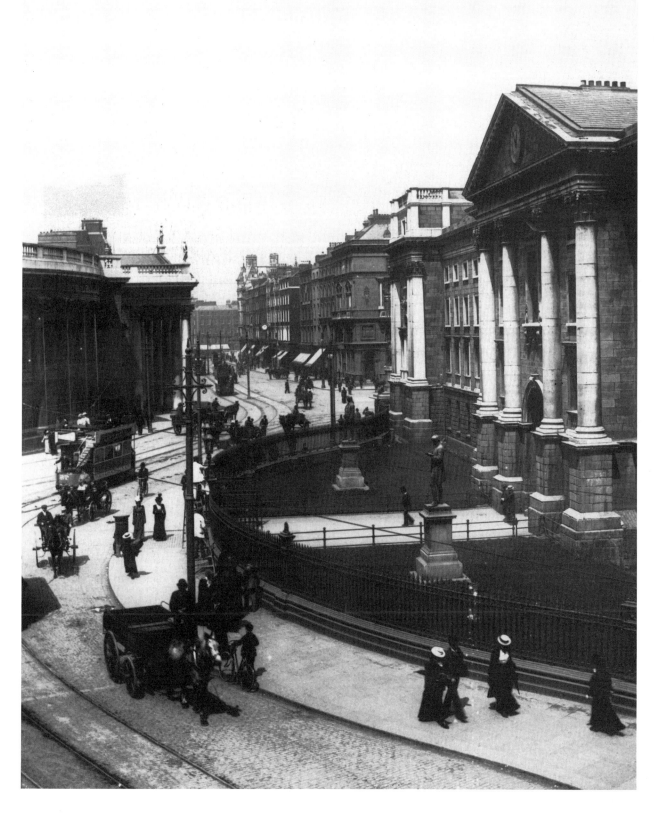

4

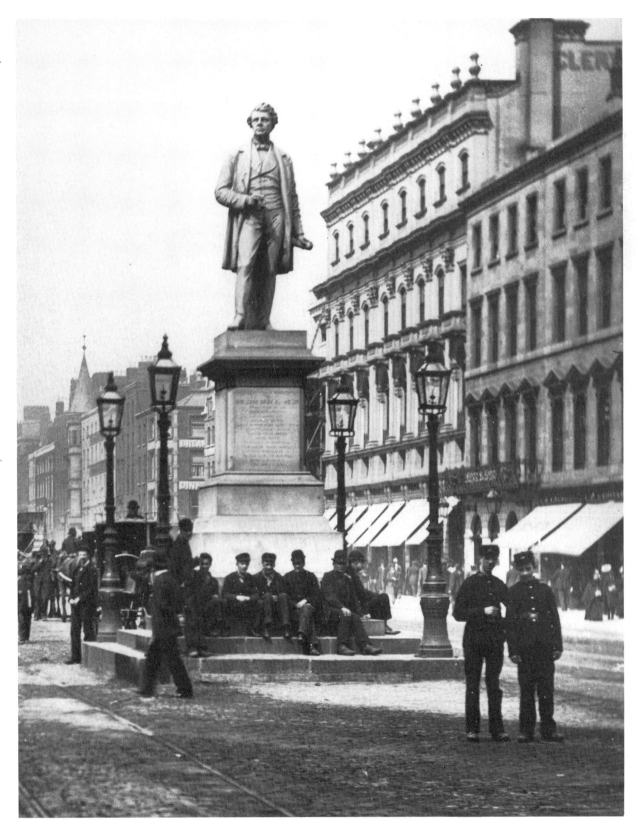

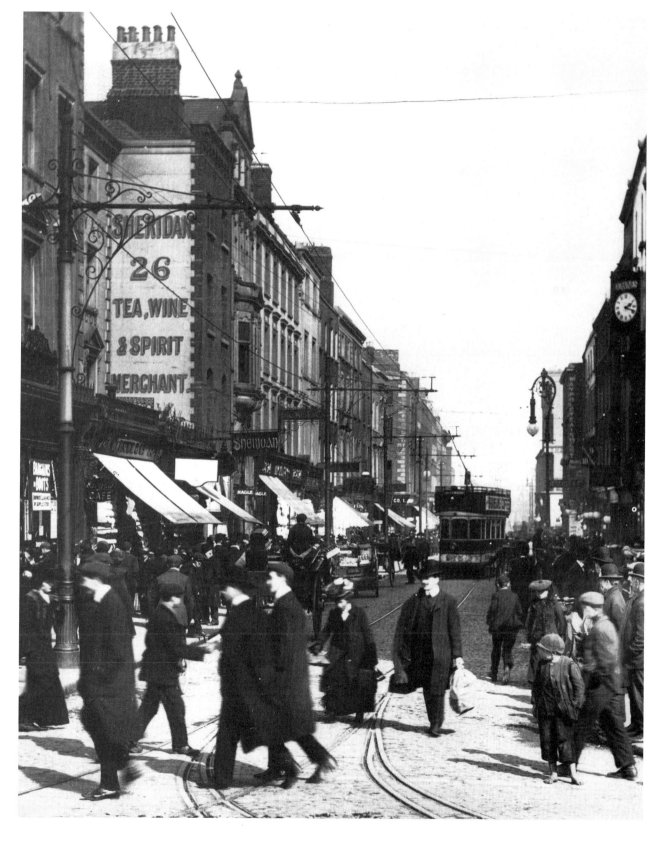

The Four Courts & River Liffey

6

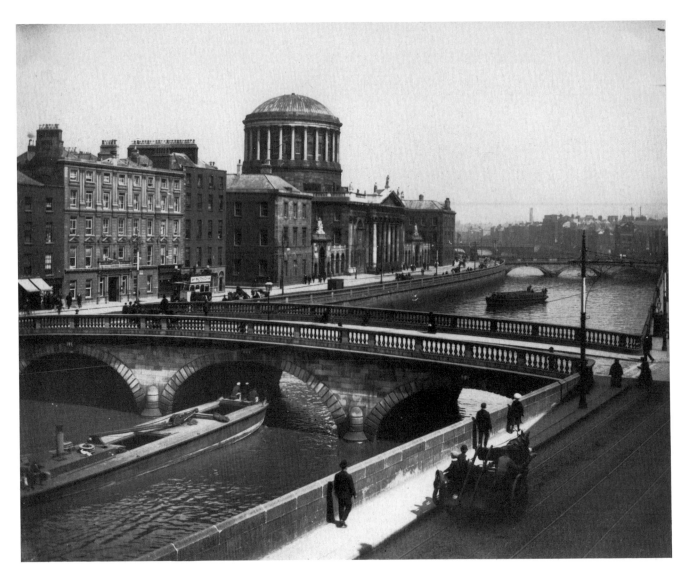

St. Stephen's Green

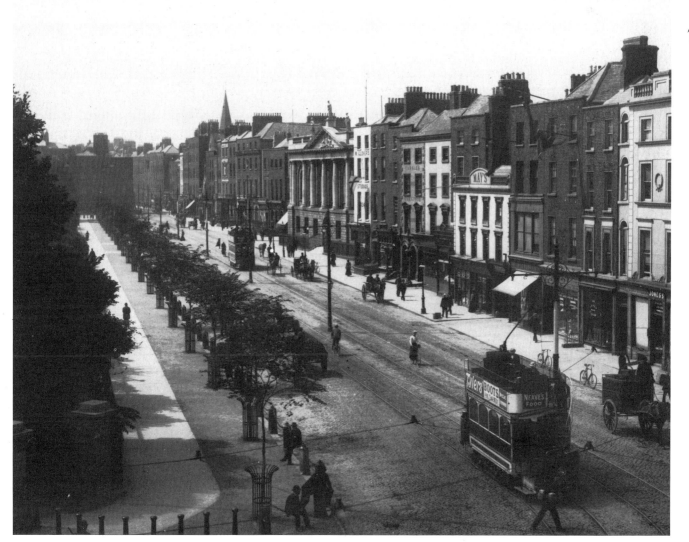

St. Stephen's Green

8

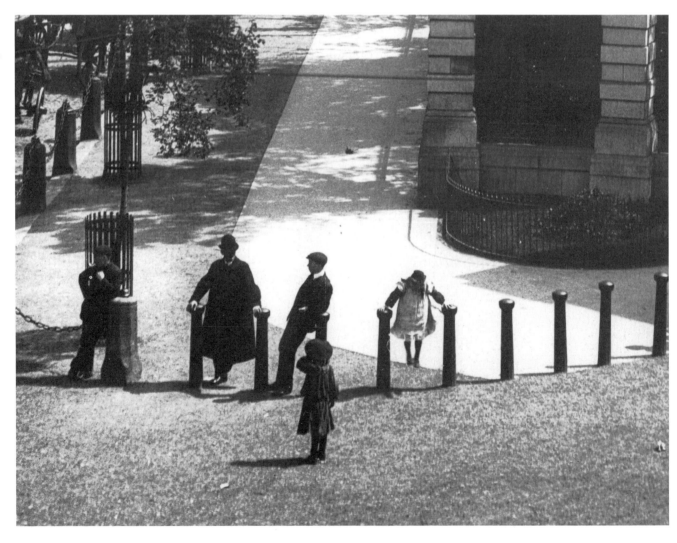

St. Stephen's Green

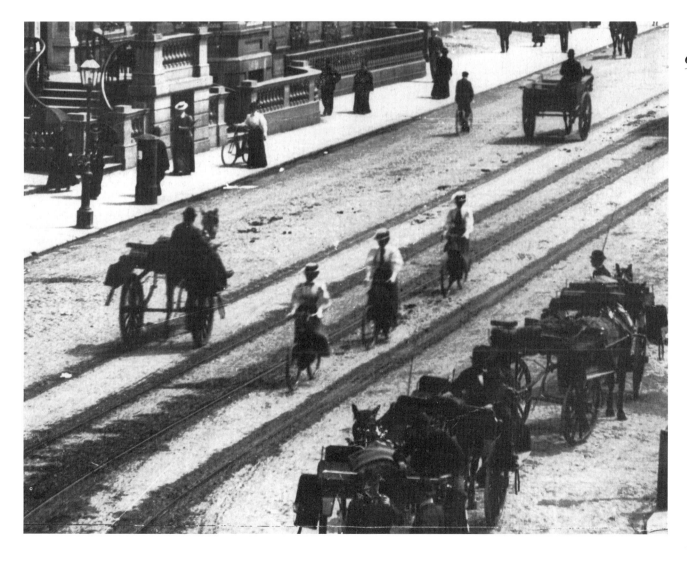

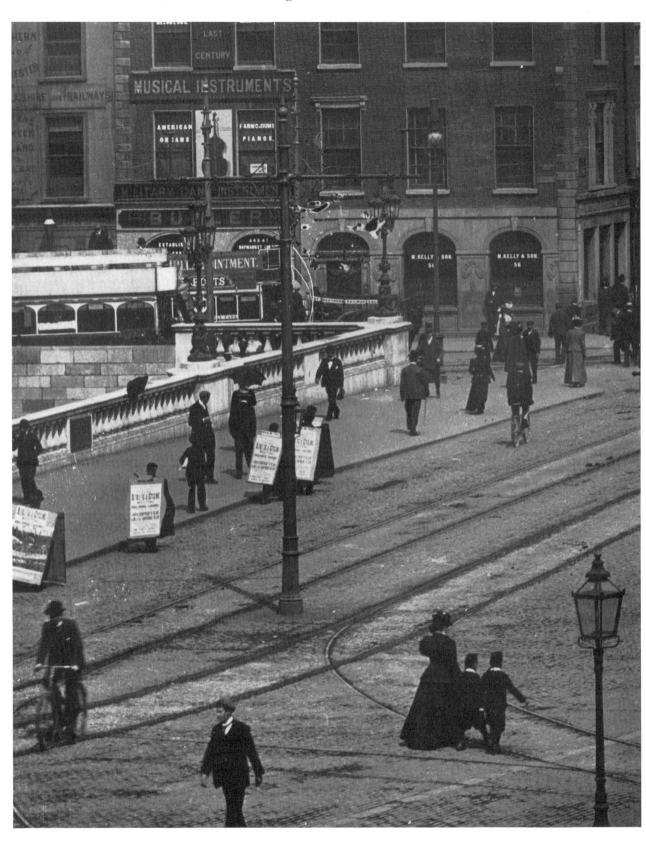

Waterhouse's Clock, Dame Street

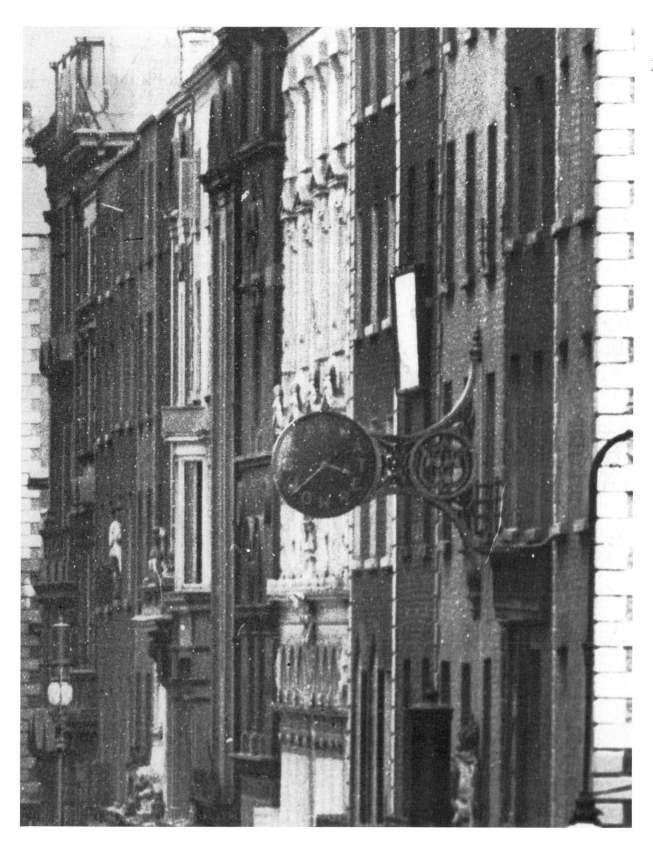

Grafton Street, 11.31 a.m.

12

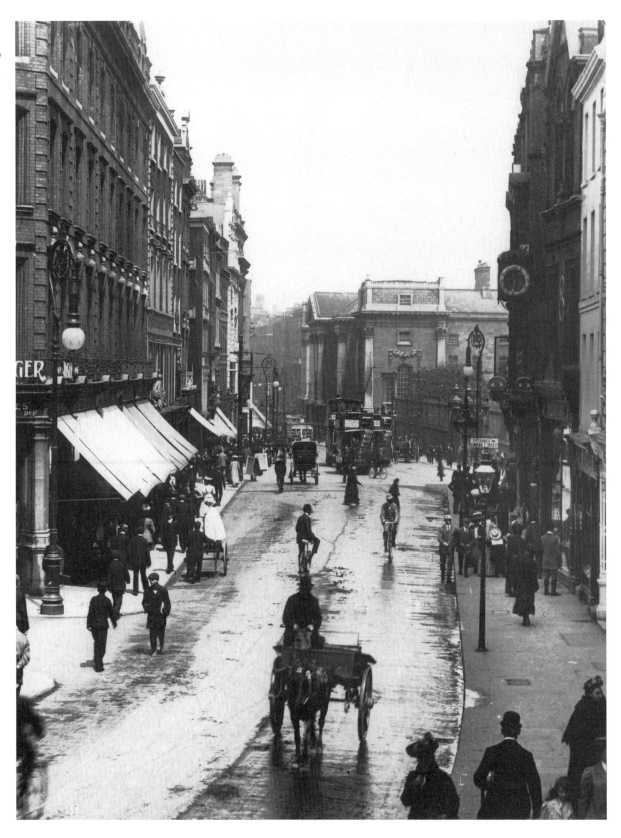

Grafton Street, 11.32 a.m.

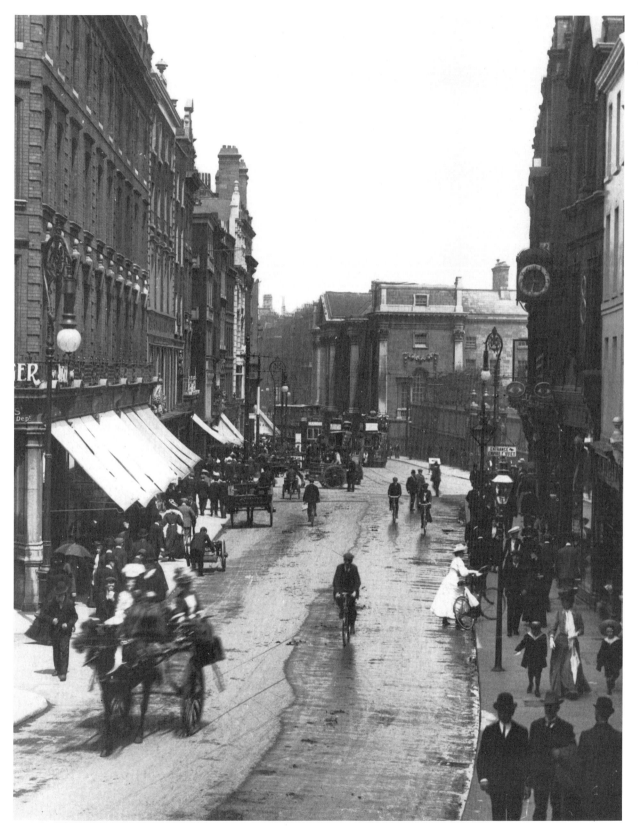

Grafton Street

14

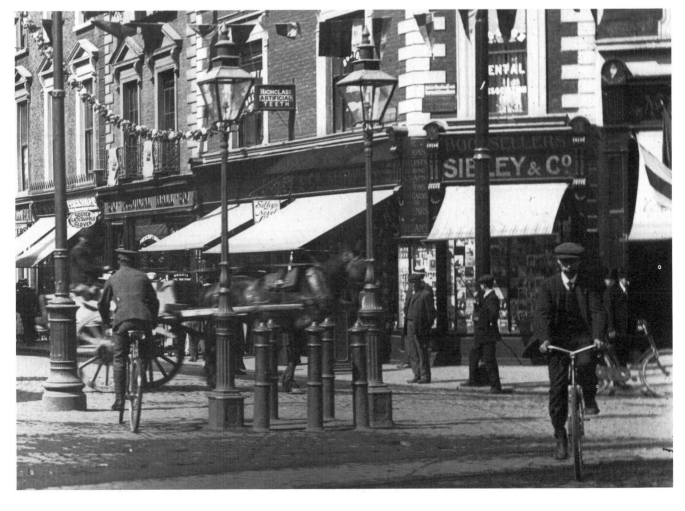

Nassau Street

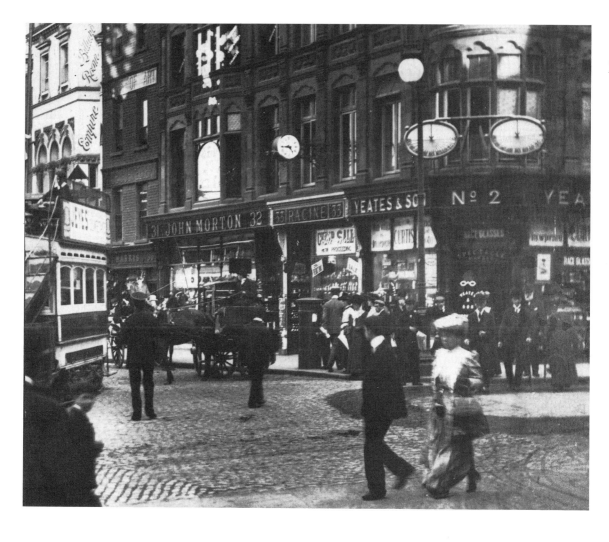

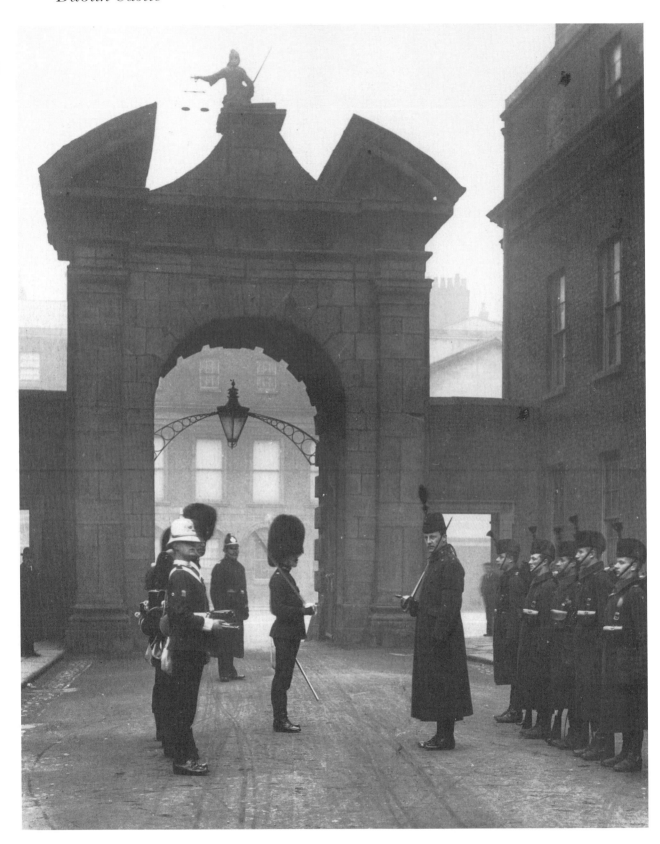

Denmark Street

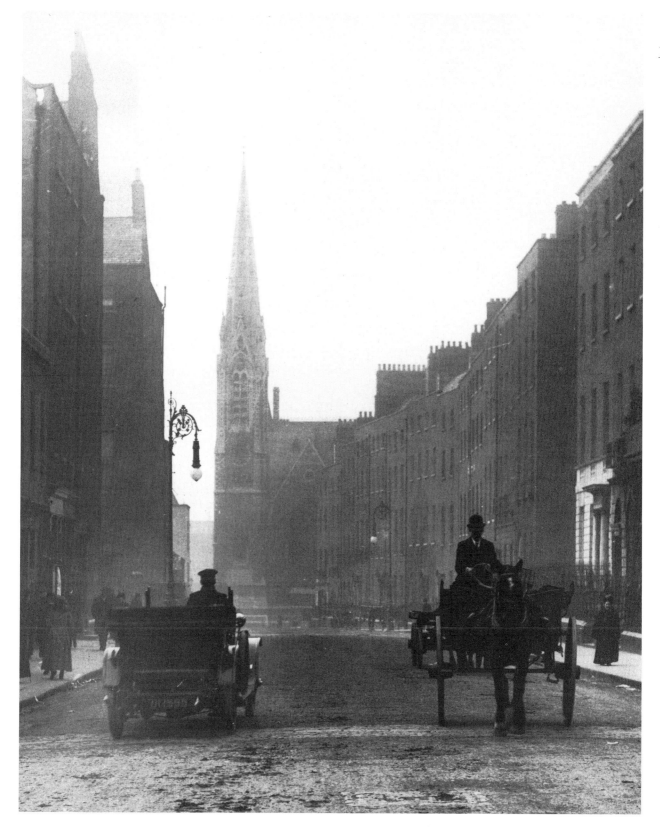

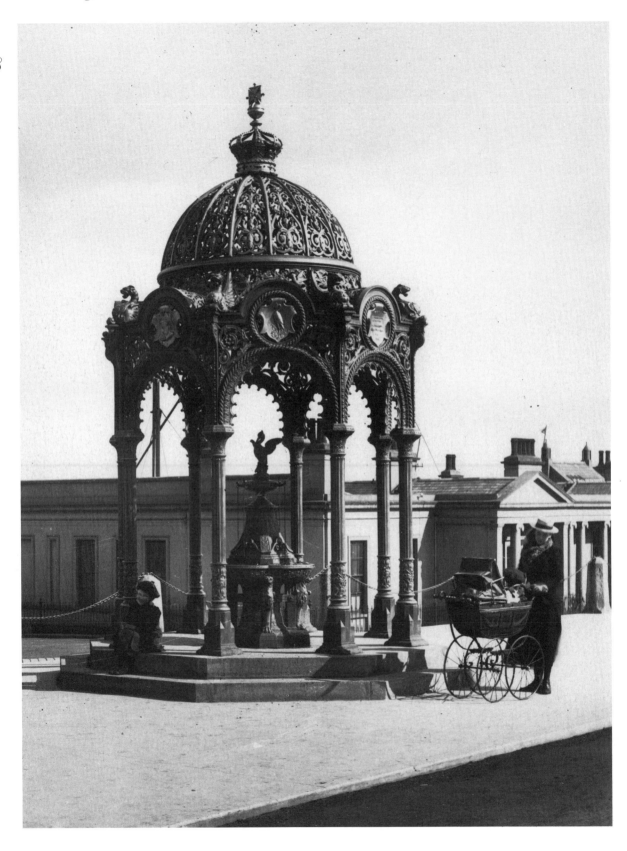

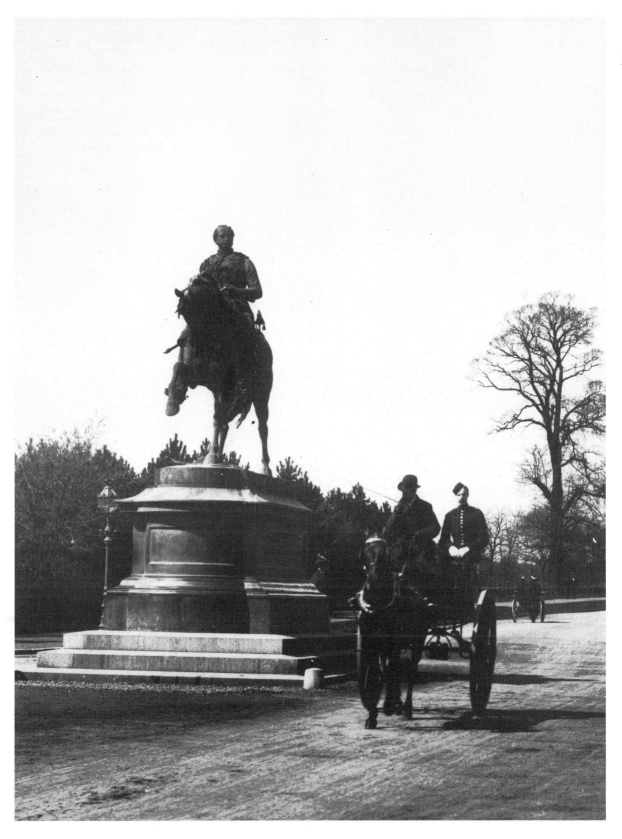

North Earl Street

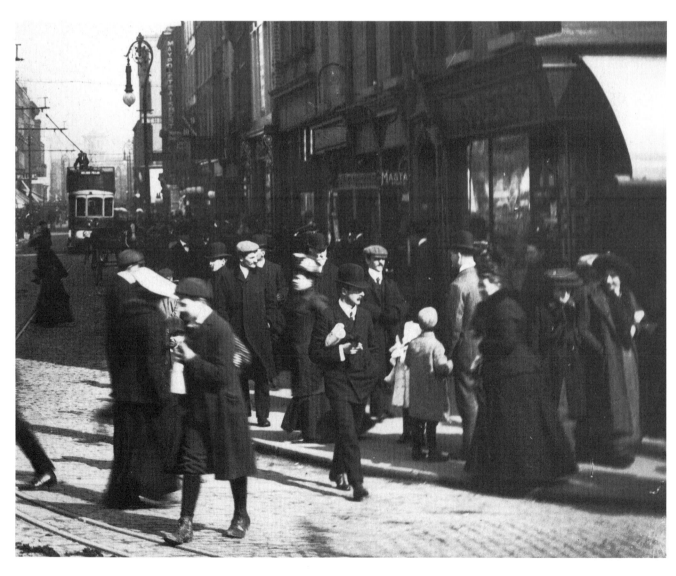

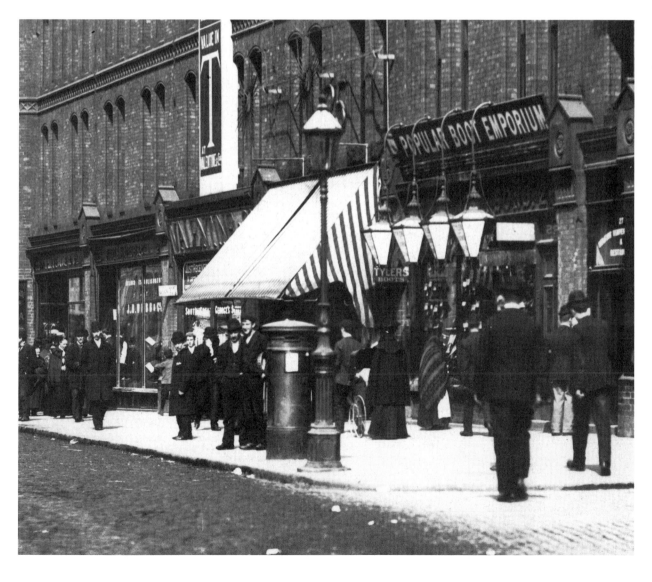

Patrick Street

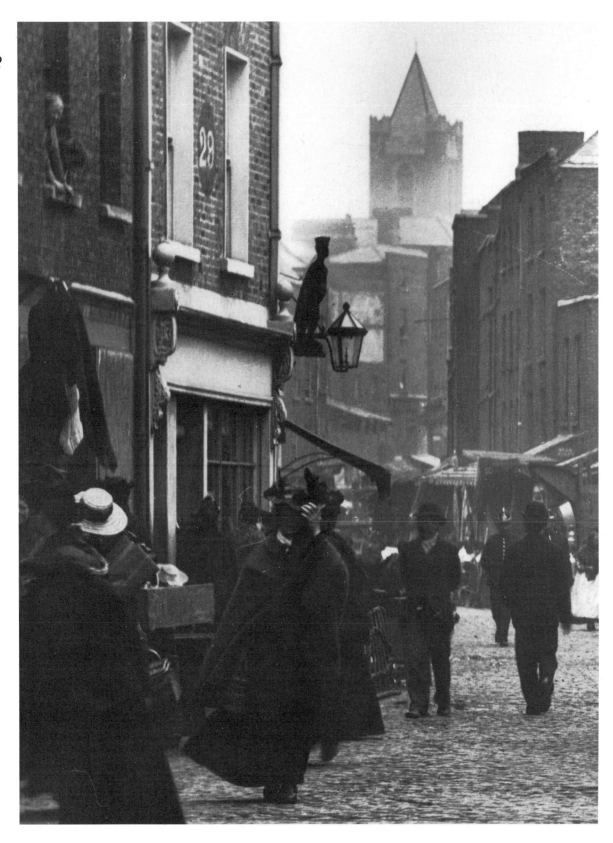

Poole Street

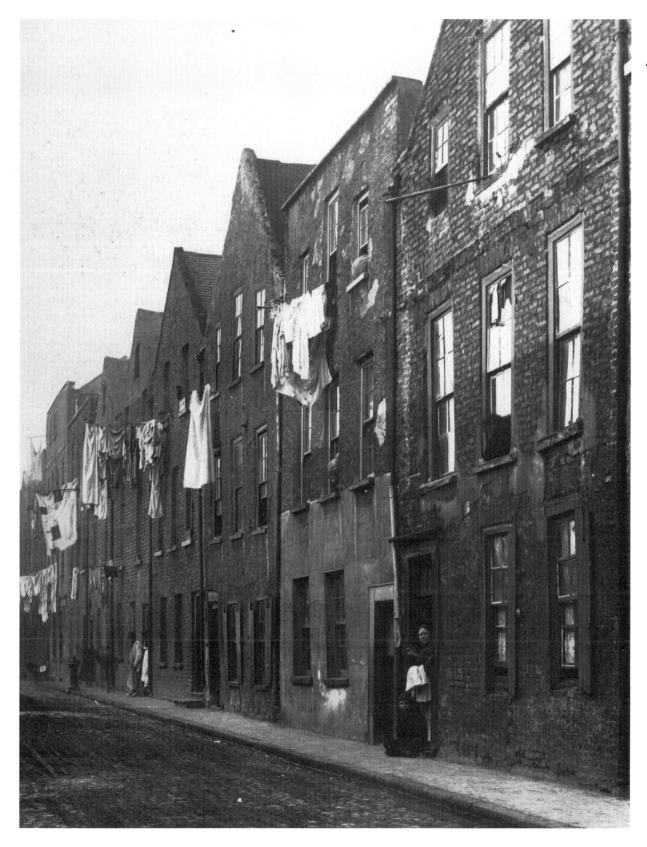

Wall's Lane

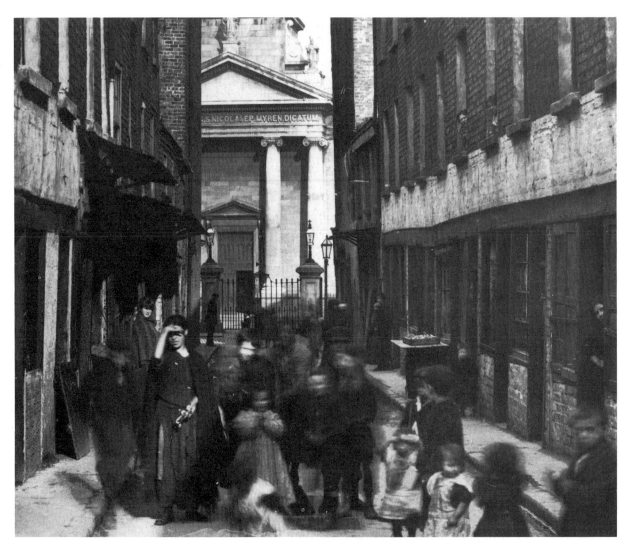

Leinster Market, D'Olier Street

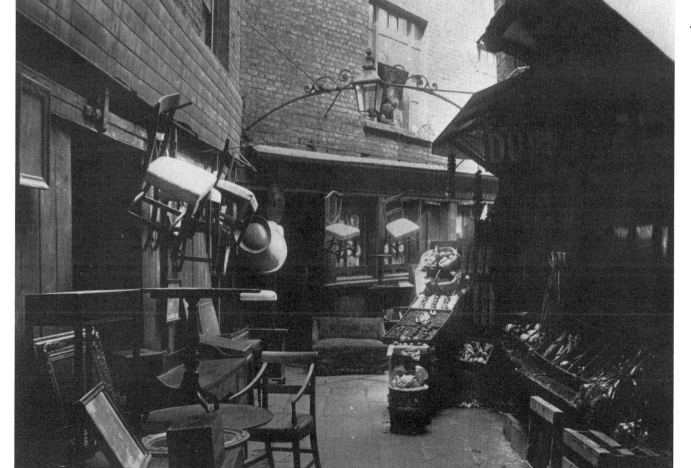

Sackville Street & Nelson Pillar

O'Connell Bridge

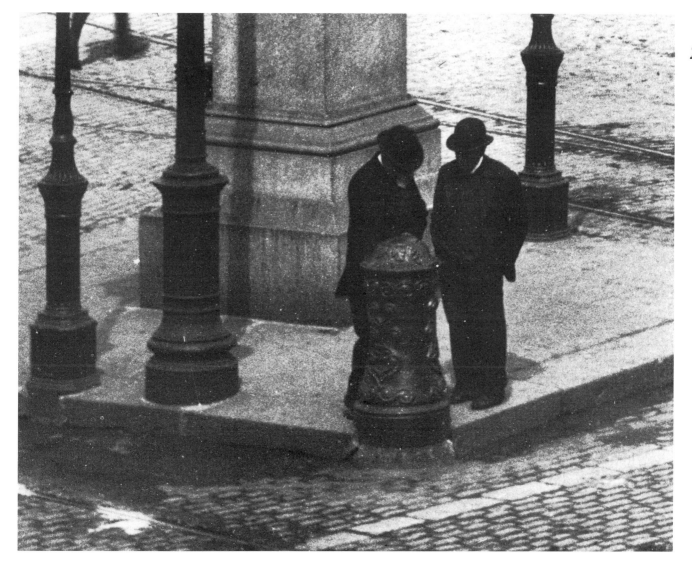

Royal procession, Phoenix Park

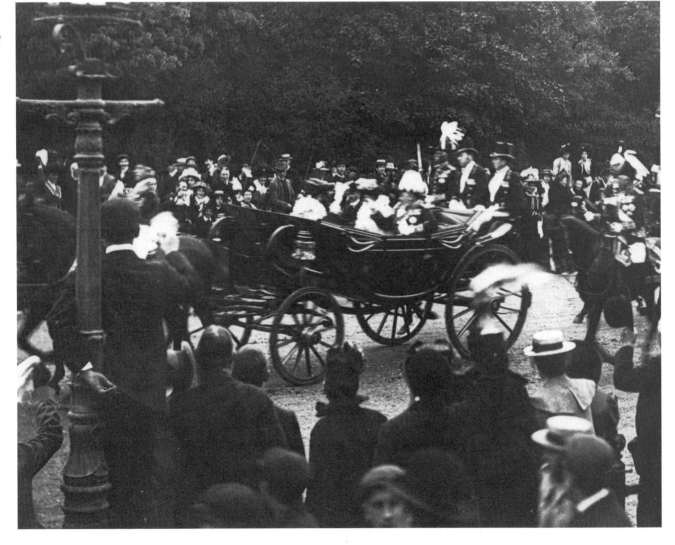

28

College Green during Queen Victoria's visit, 1901

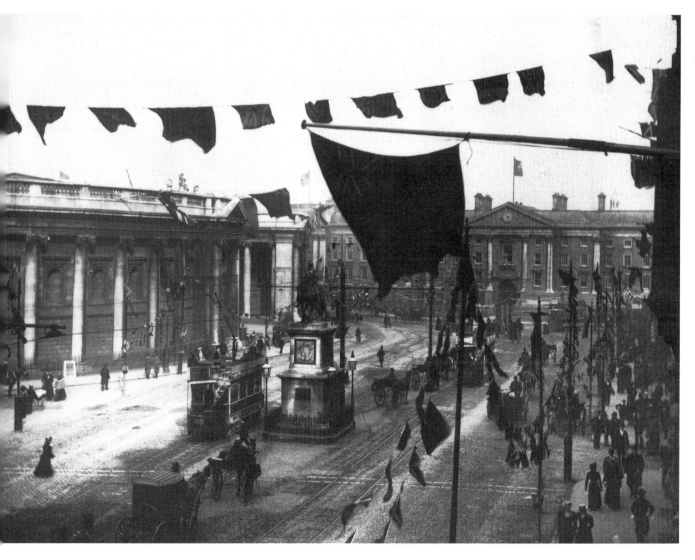

Custom House & River Liffey

30

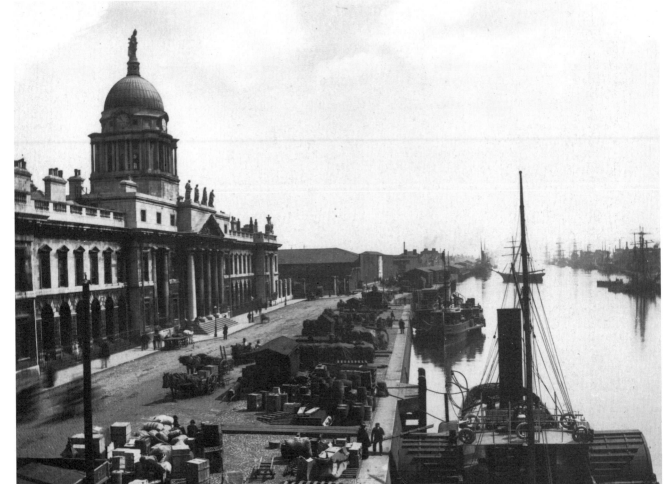

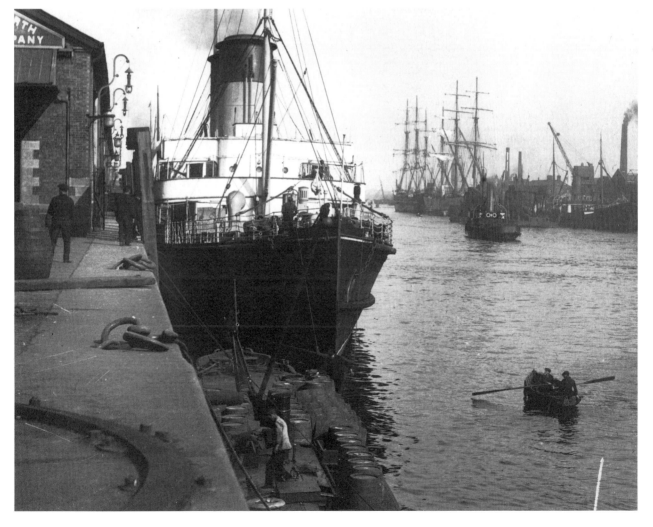

32
3.04 p.m.

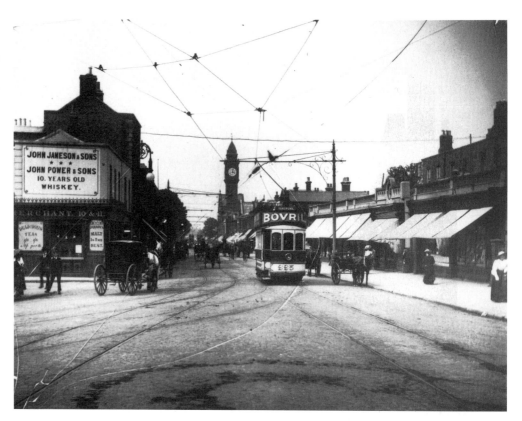

33
3.05 p.m.

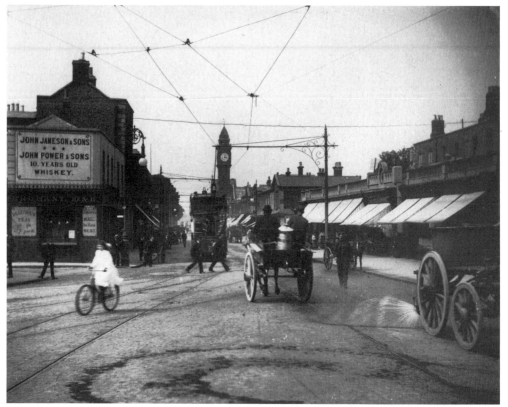

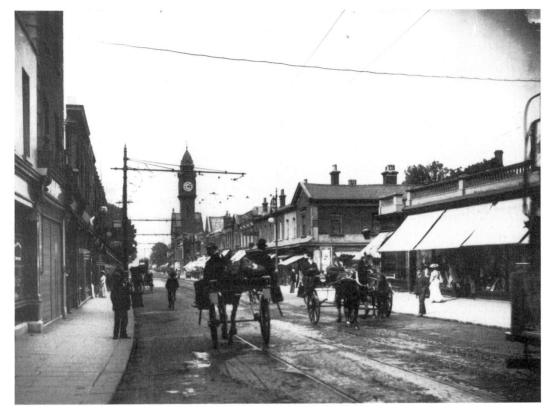

34
3.09 p.m.

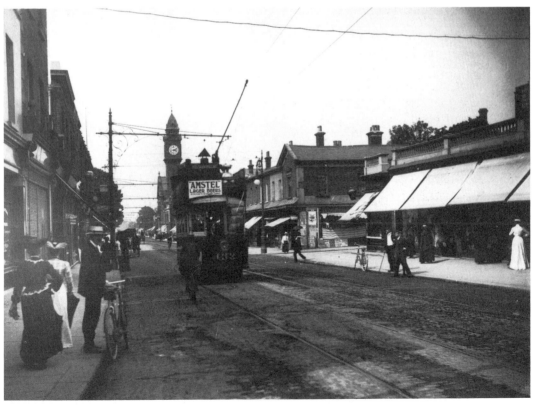

35
3.10 p.m.

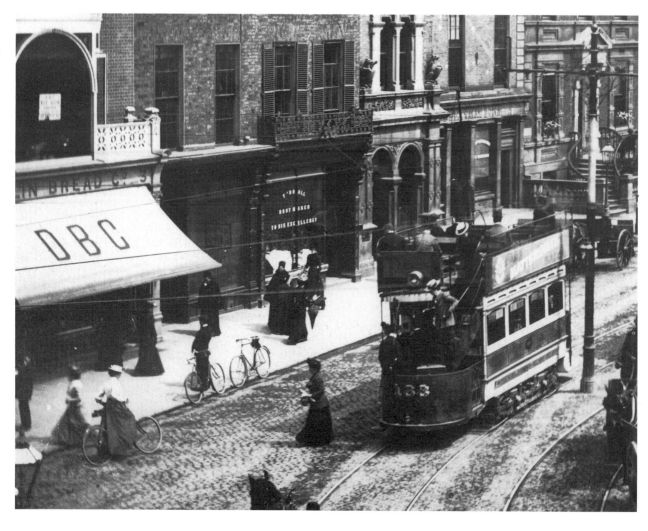

St. Stephen's Green

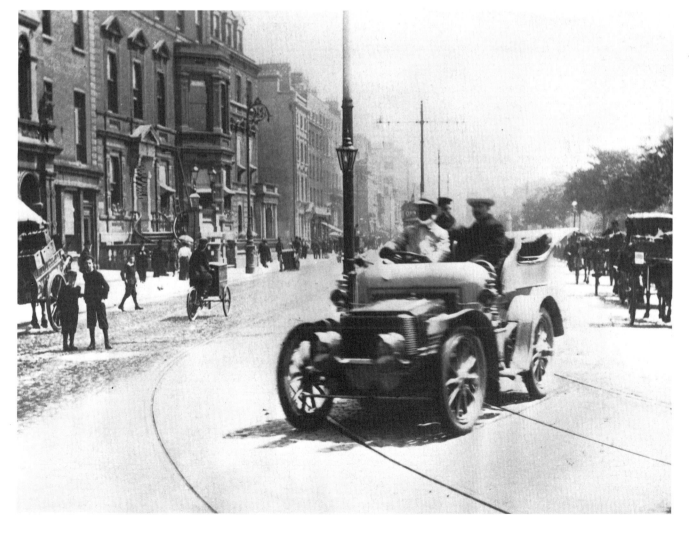

Royal Irish Constabulary Depot, Phoenix Park

38

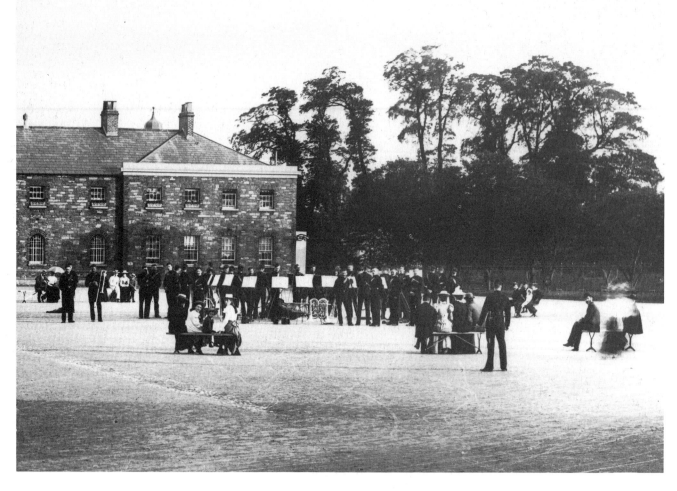

Kingstown Pier

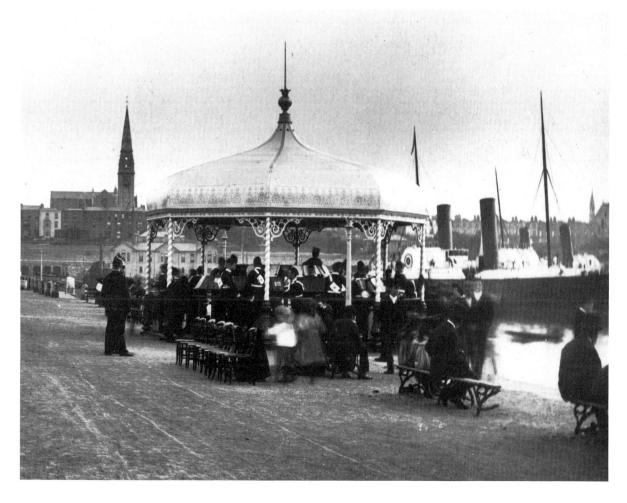

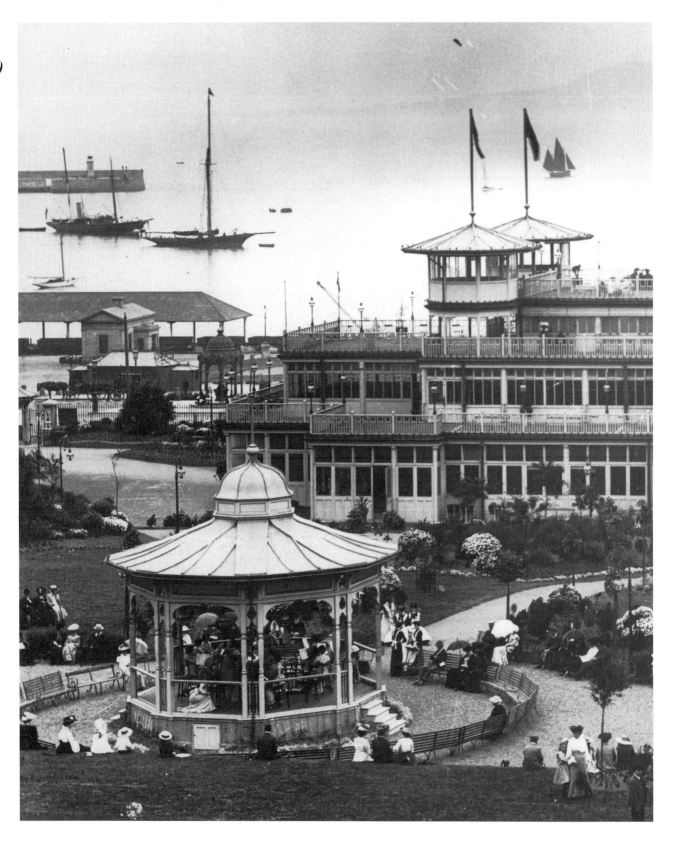

Kingstown Pavilion

Kingstown Pavilion

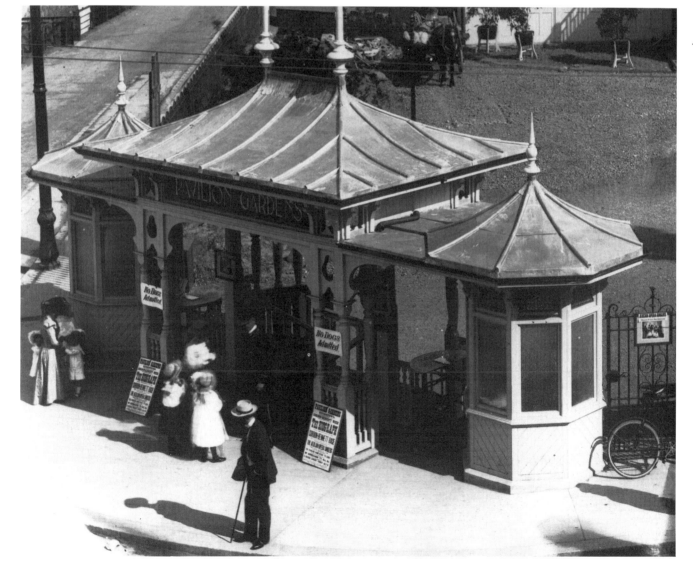

Mail Boat Pier, Kingstown

42

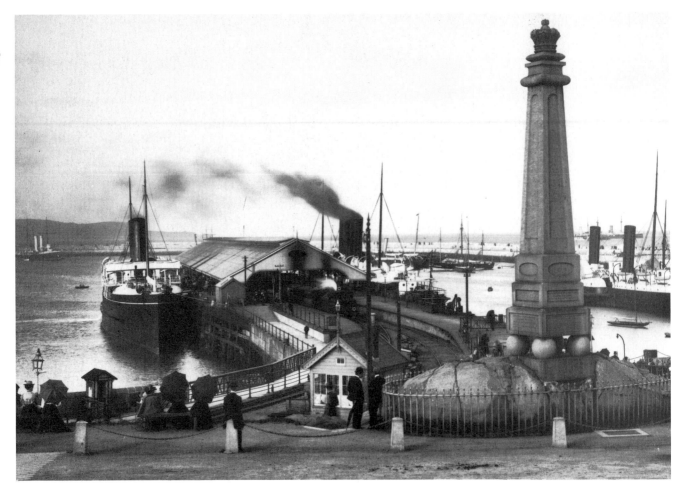

Yachting, Kingstown

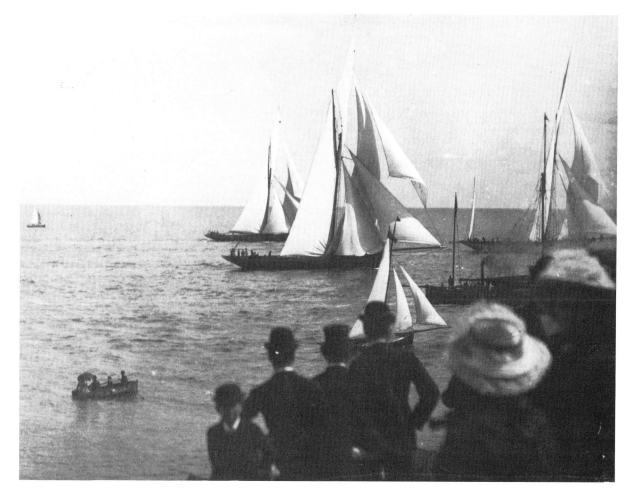

Herbert Park

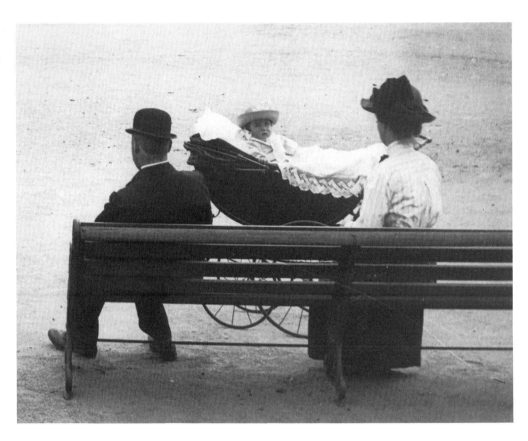

Fade Street

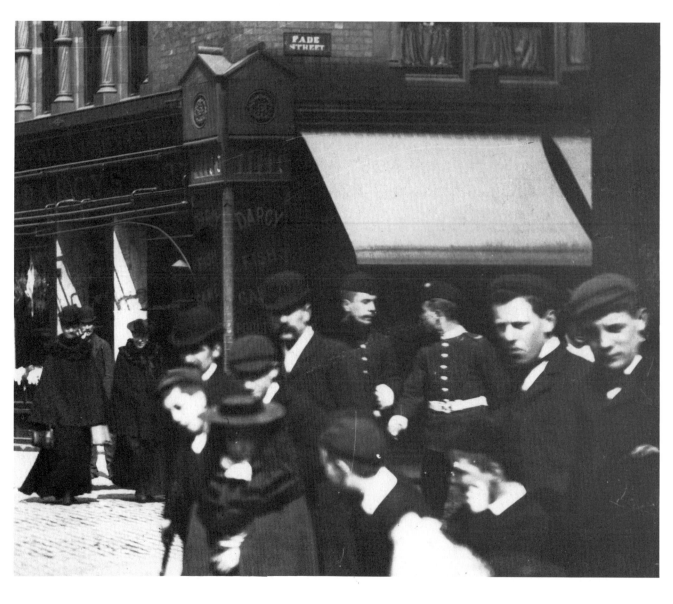

Michael's Lane

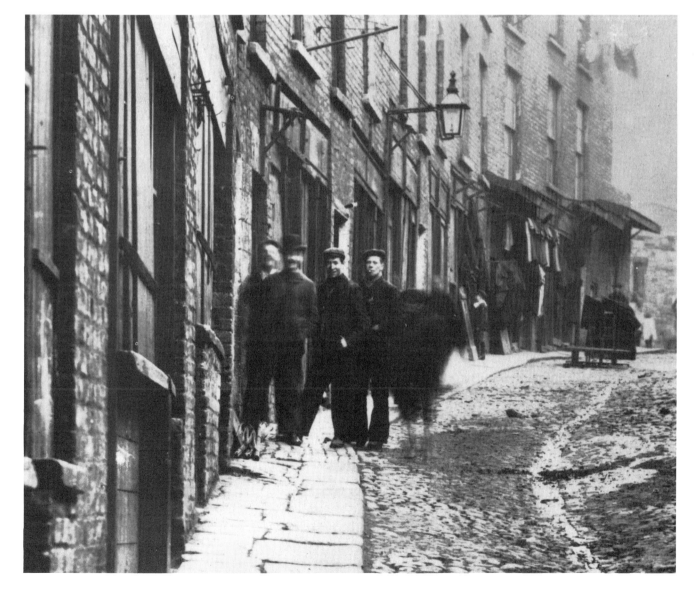

Marlborough Barracks

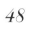

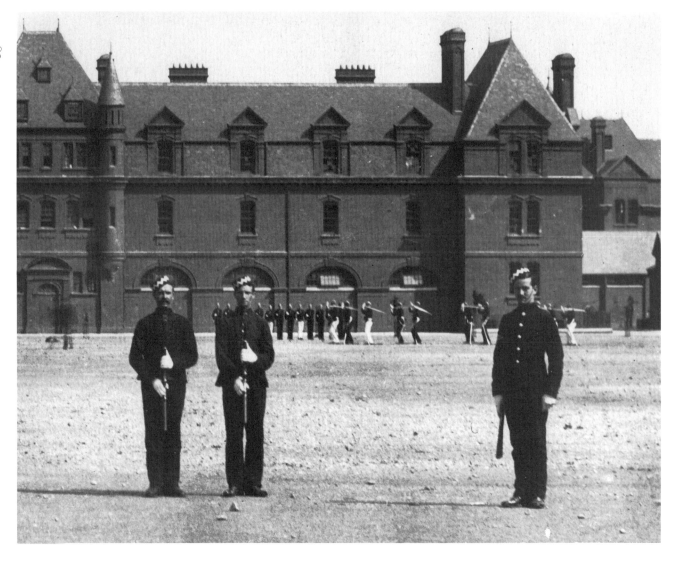

Royal Irish Constabulary Depot, Phoenix Park

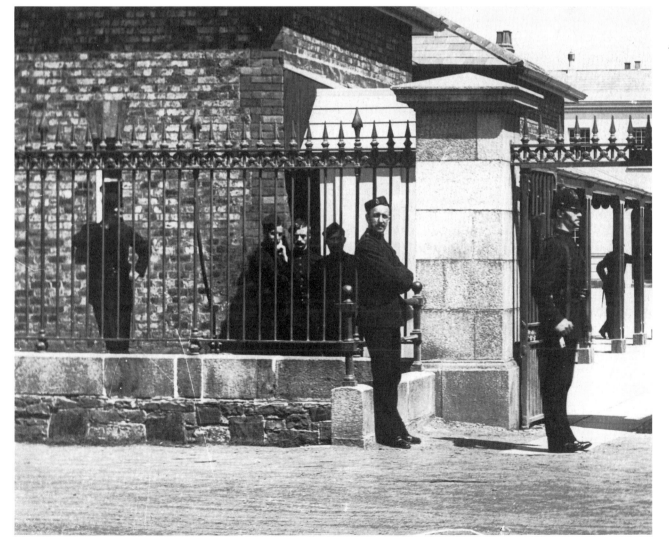

Grafton Street

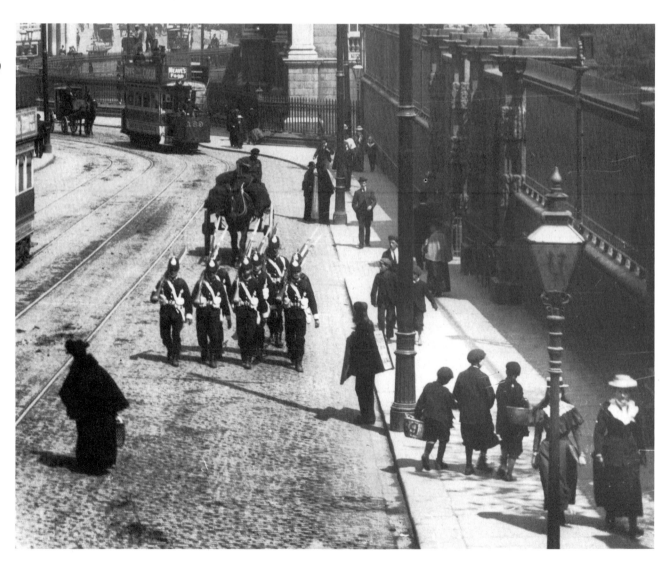

Castle Gate, Cork Hill

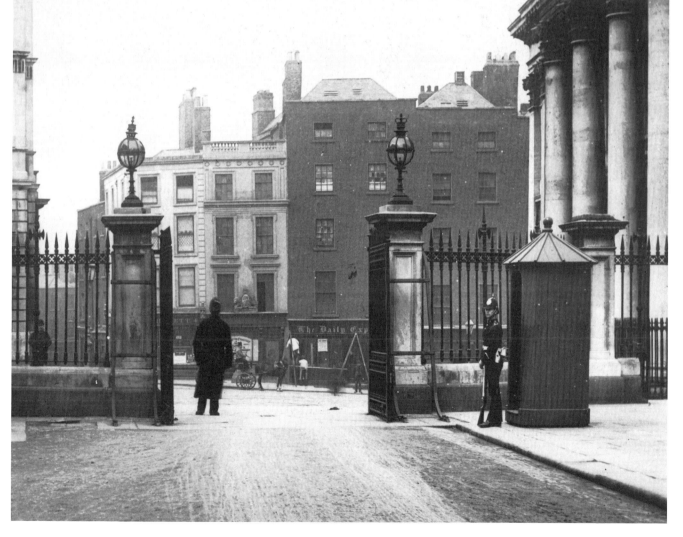

Terenure

52

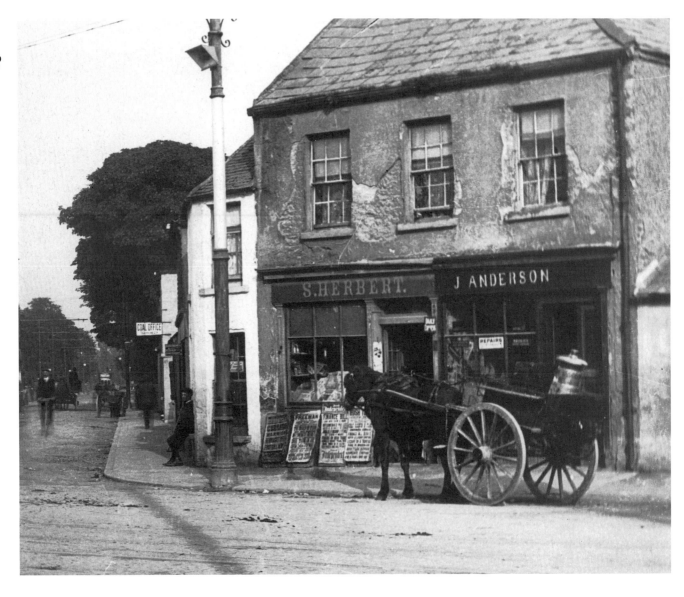

Chapelizod

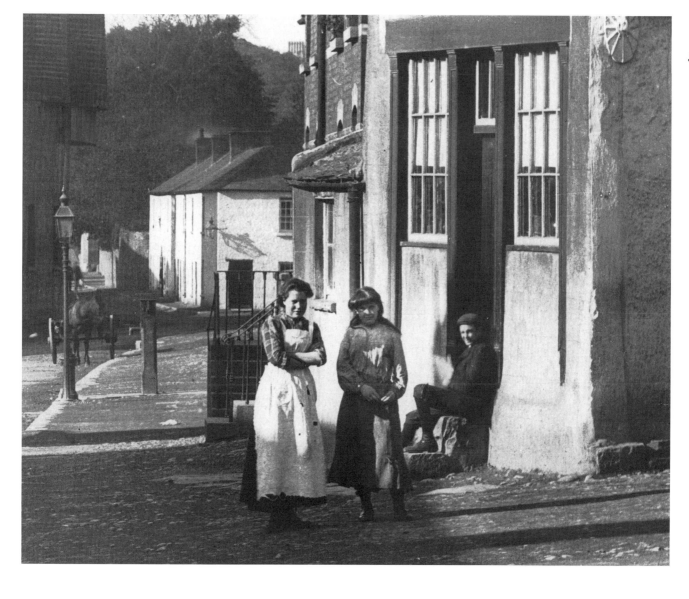

Gresham Hotel, Sackville Street

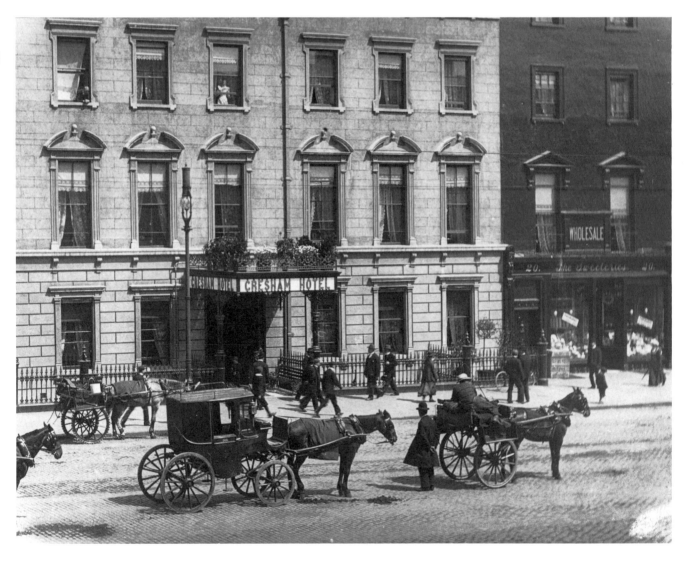

Shelbourne Hotel, St. Stephen's Green

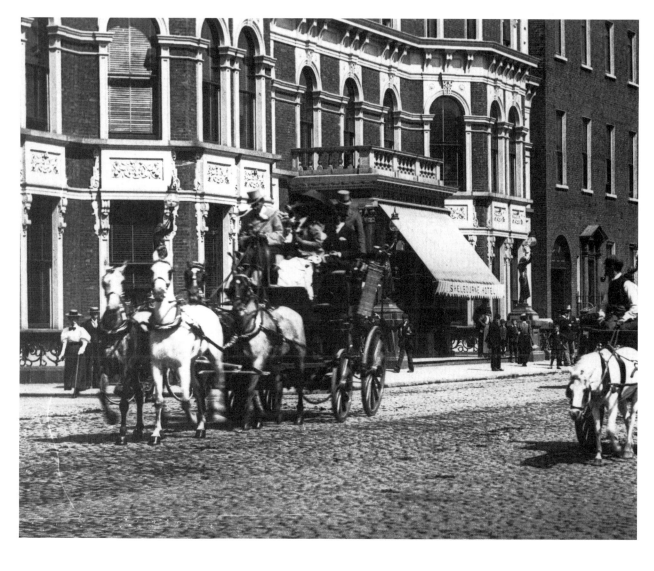

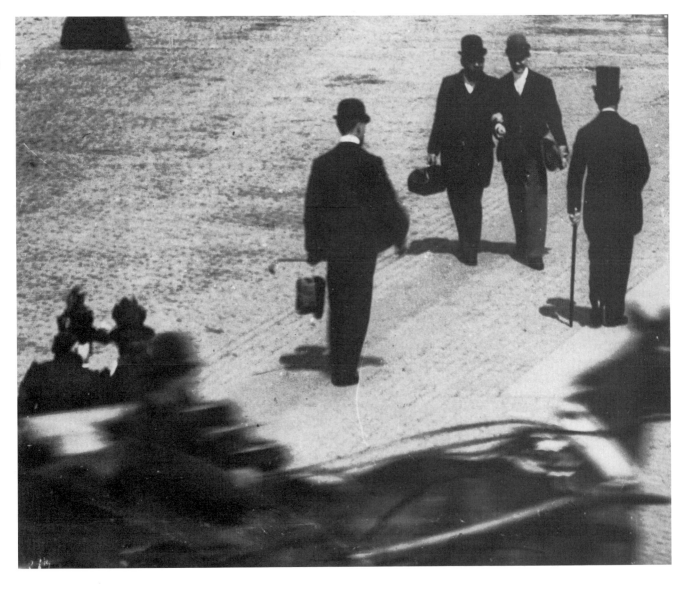

Sackville Street

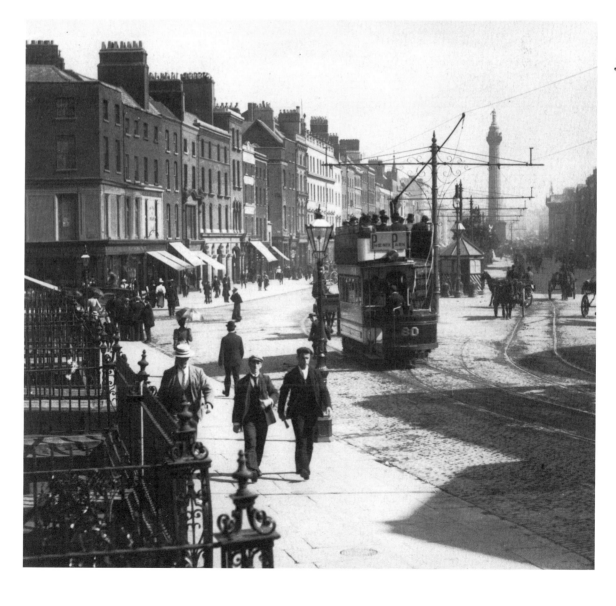

North Circular Road

58

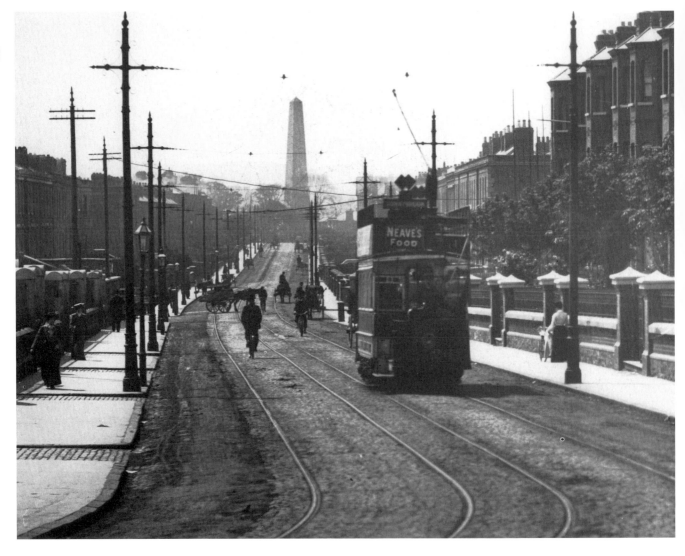

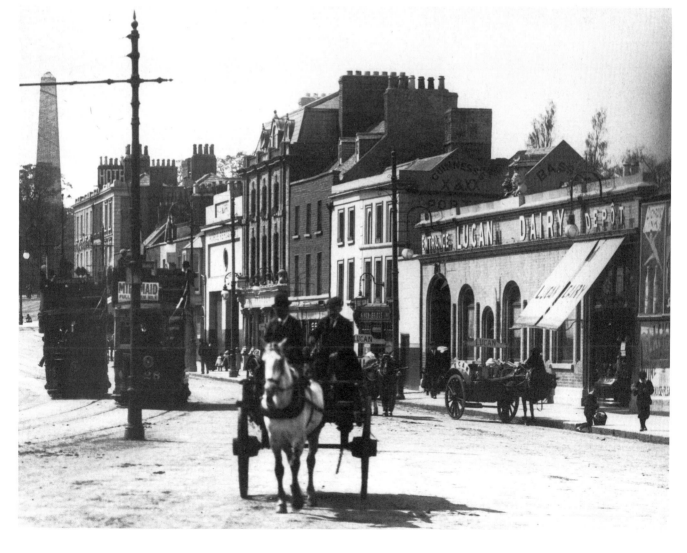

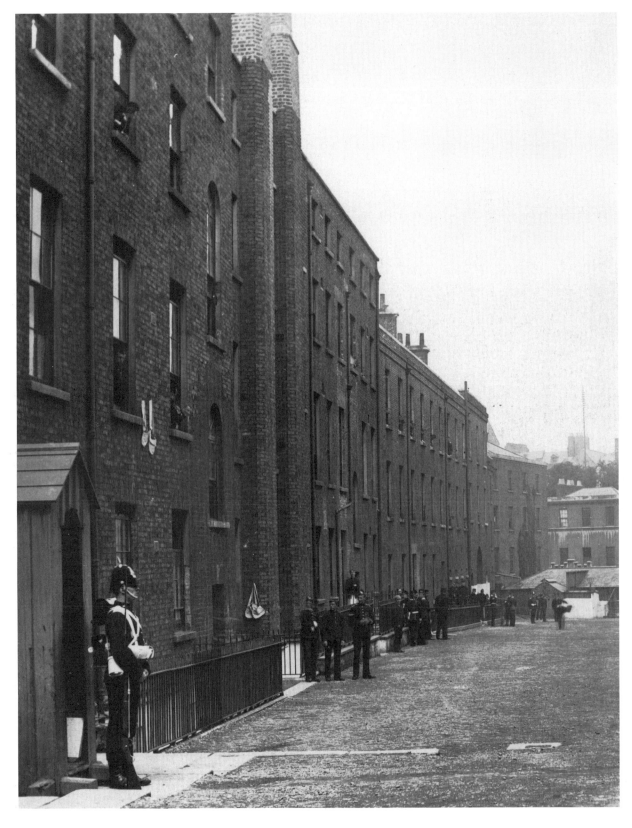

O'Connell Bridge & D'Olier Street

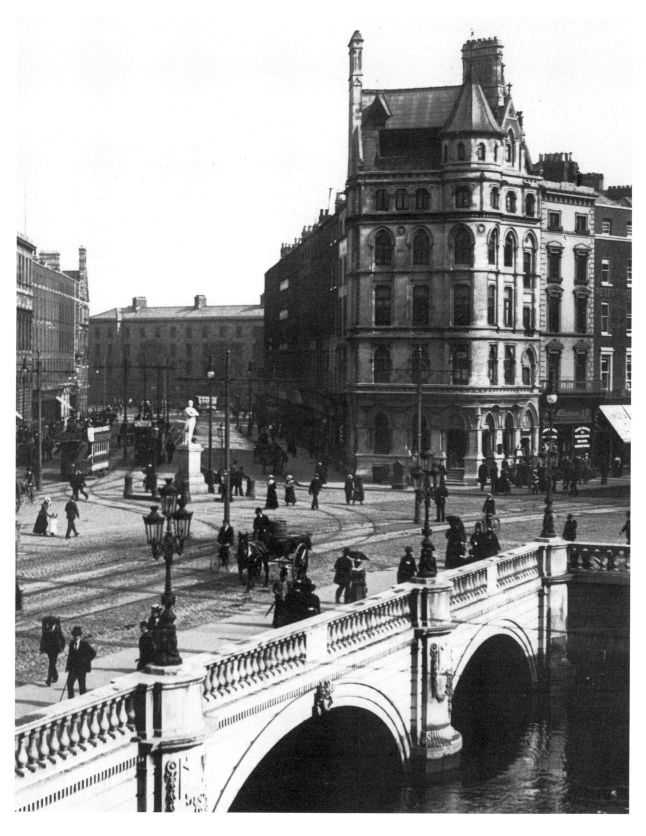

Parnell's Grave, Glasnevin

62

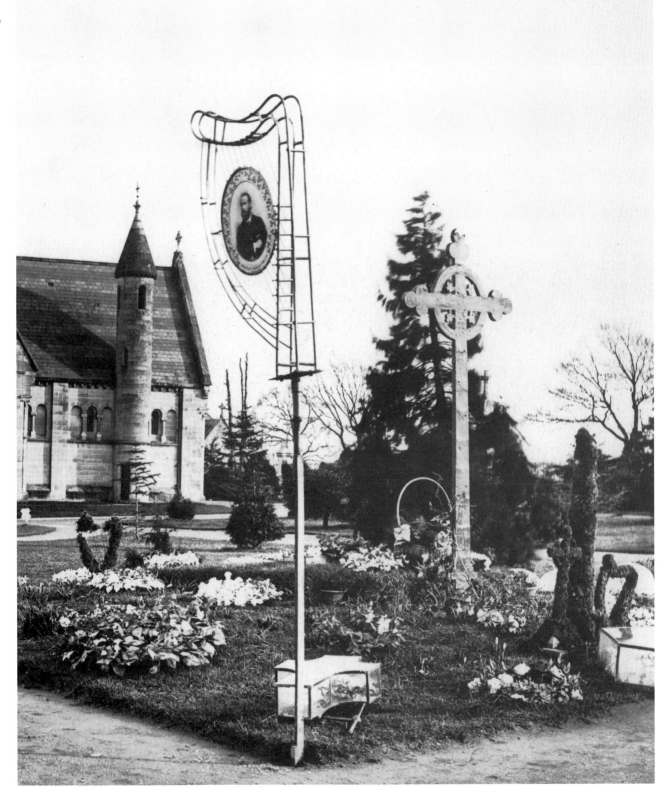

Eccles Street & St. George's Church

64

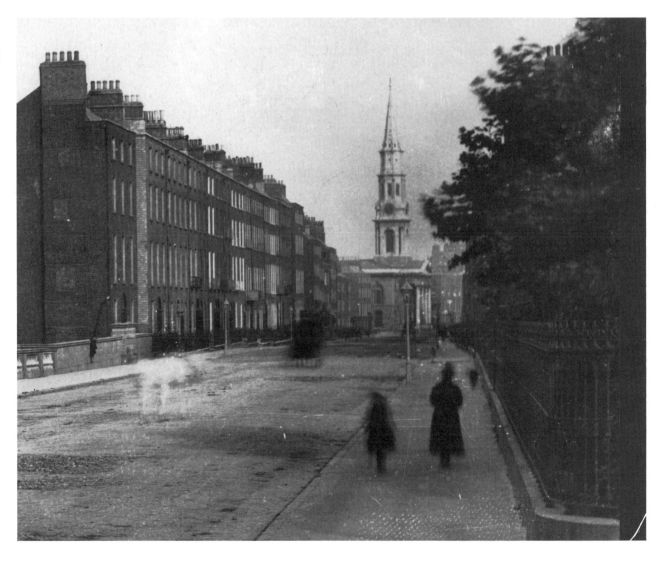

Kildare Street

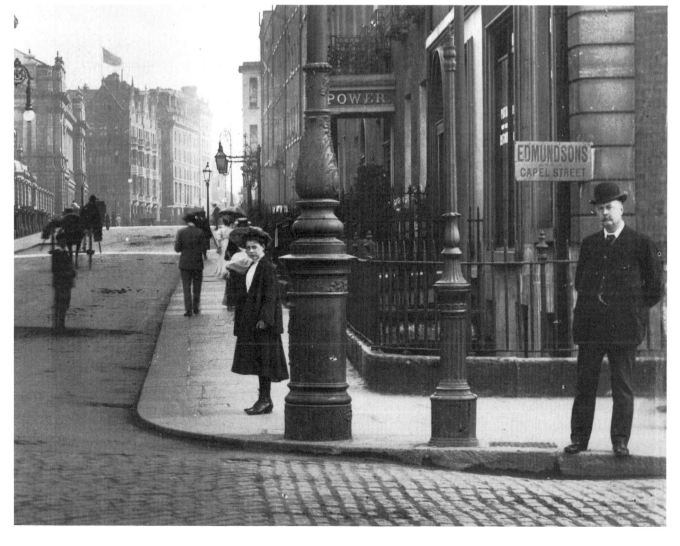

Hole in the Wall, Phoenix Park

66

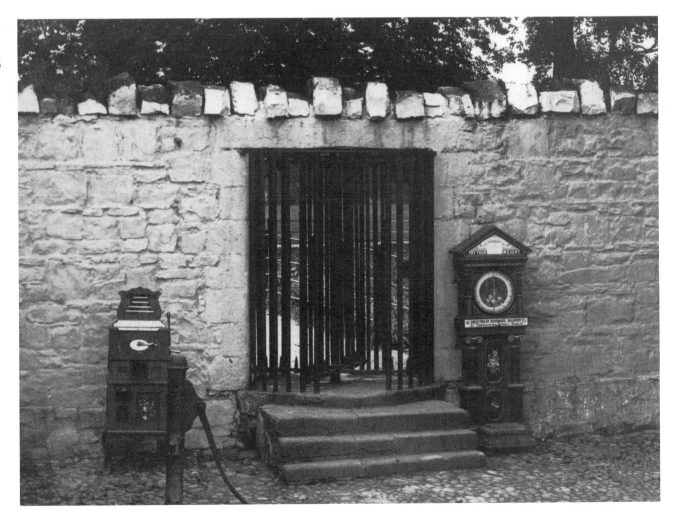

Wellington Barracks

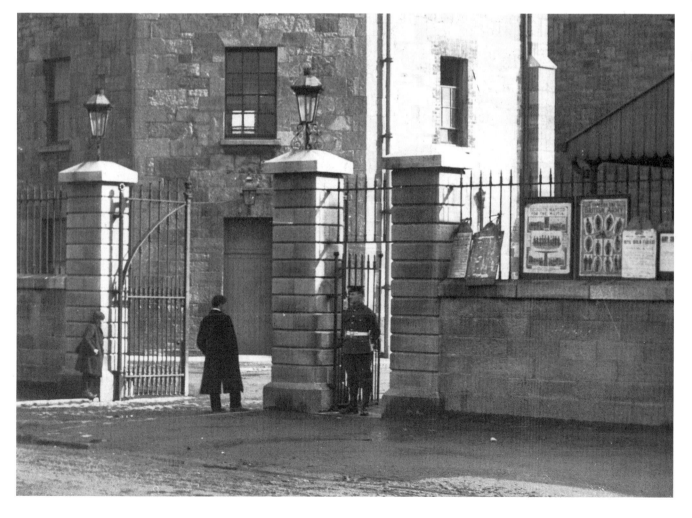

Kingsbridge

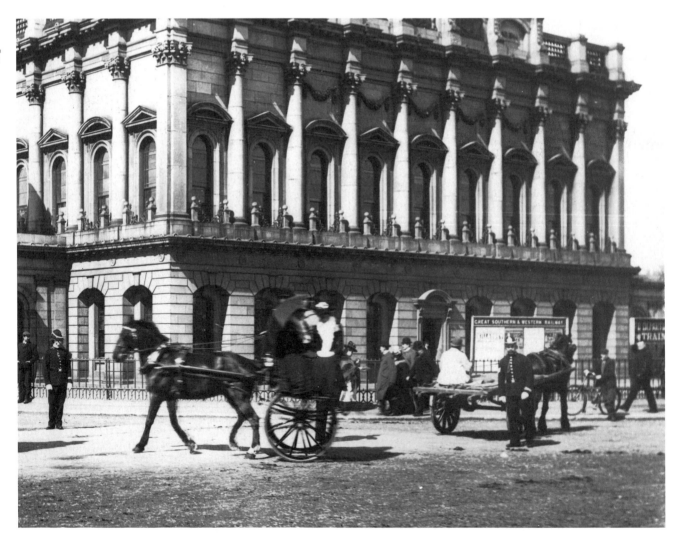

National Library

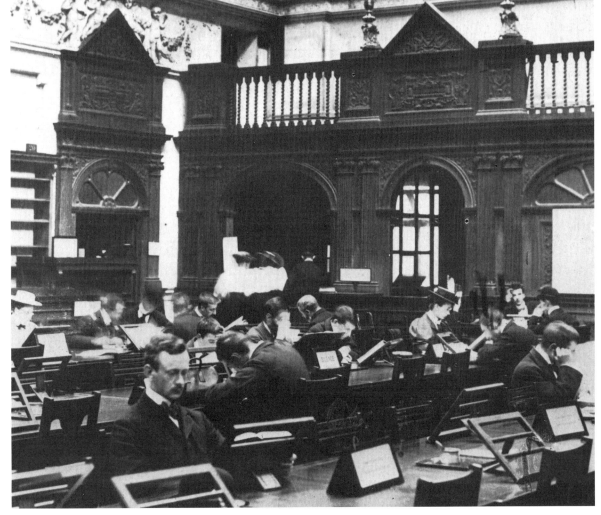

70

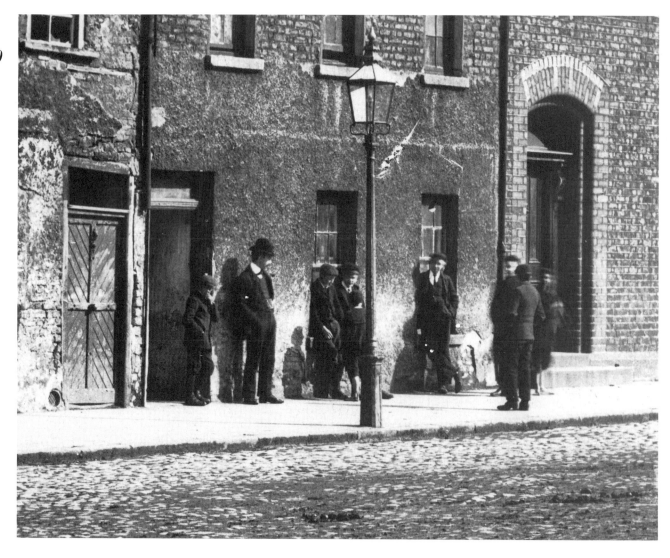

Michael's Lane

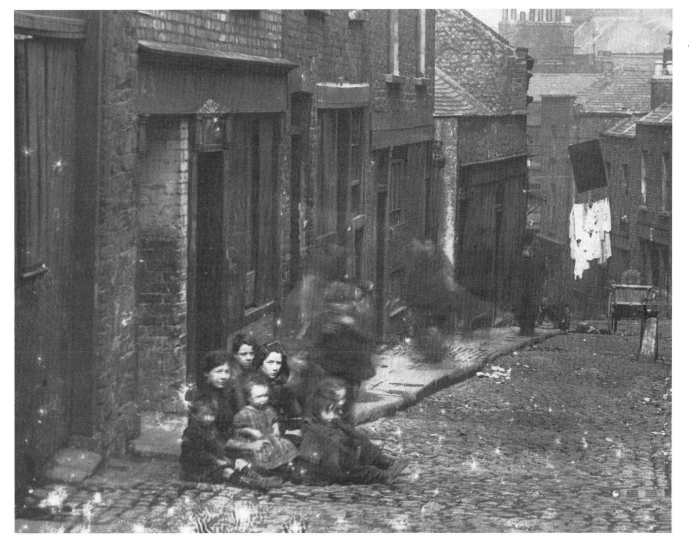

Grafton Street

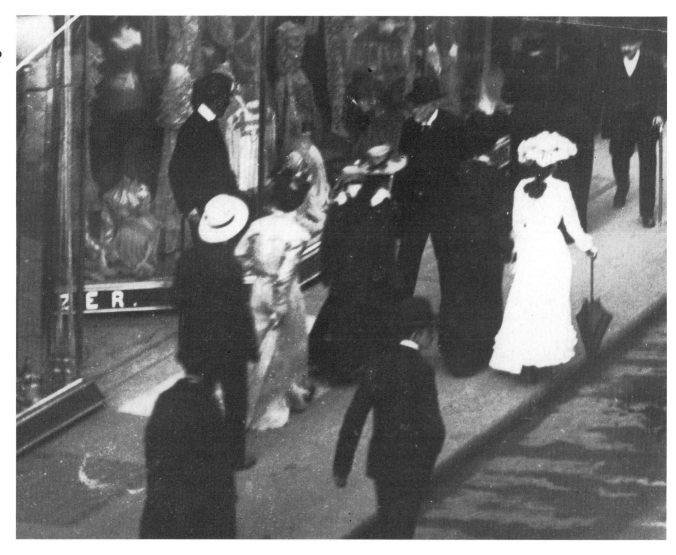

Burgh Quay

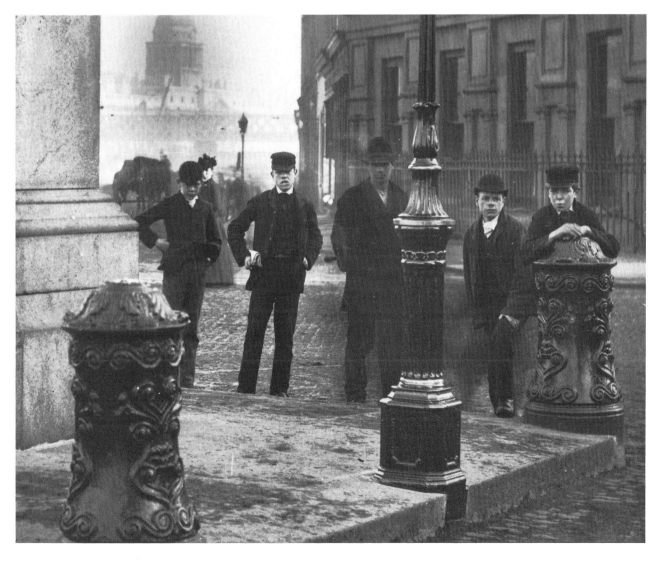

List of Illustrations

DEPARTED

Index